"A searing, lyric voyage through a COVID-stricken America that is also a self-portrait of Maharidge's own earlier life as a 'blue collar' writer. In the strange present, we travel with him to homeless encampments and meatpacking facilities, seeing up close all the deprecations of Trump's America and how they echo our country's melancholy past."

—Alissa Quart, author of *Squeezed: Why Our Families Can't Afford America*

Poverty is both reality and destiny for increasing numbers of people in the 2020s and, as Maharidge discovers spray-painted inside an abandoned gas station in the California desert, it is a fate often handed down from birth. Motivated by this haunting phrase—"Fucked at Birth"—Maharidge explores the realities of being poor in America in the coming decade, as pandemic, economic crisis and social revolution up-end the country.

Part raw memoir, part dogged, investigative journalism, and featuring photos from across the US, *Fucked At Birth* channels the history of poverty in America to help inform the voices Maharidge encounters daily. In an unprecedented time of social activism amid economic crisis, when voices everywhere are rising up for change, Maharidge's journey channels the spirits of George Orwell and James Agee, raising questions about class, privilege, and the very concept of "upward mobility," while serving as a final call to action.

From Sacramento to Denver, Youngstown to New York City, *Fucked At Birth* dares readers to see the human suffering most, and to finally—after decades we are going to do about it.

T0126355

Fucked at Birth

Recalibrating the American Dream for the 2020s

Dale Maharidge

The Unnamed Press
Los Angeles, CA

AN UNNAMED PRESS BOOK

www.unnamedpress.com

Unnamed Press, and the colophon, are registered trademarks of Unnamed Media LLC.

ISBN: 978-1951213220

Library of Congress Cataloging-in-Publication Data

Names: Maharidge, Dale, author.
Title: Fucked at birth : recalibrating the American dream for the 2020s / Dale Maharidge.
Description: First edition. | Los Angeles, CA : The Unnamed Press, [2020] |
Identifiers: LCCN 2020042635 (print) | LCCN 2020042636 (ebook) | ISBN
9781951213220 (trade paperback) | ISBN 9781951213237 (ebook)
Subjects: LCSH: Poor—United States—Social conditions—21st century. | Poor—United
States—History. | American Dream. | United States—Social conditions—21st century.
| United States—Economic conditions—21st century.
Classification: LCC HC110.P6 M275 2020 (print) | LCC HC110.P6 (ebook) | DDC
305.5/690973—dc23
LC record available at https:/ /lccn.loc.gov/2020042635
LC ebook record available at https:/ /lccn.loc.gov/2020042636

This book is a work of nonfiction.

Cover Photograph by Dale Maharidge
Designed and Typeset by Jaya Nicely

Manufactured in the United States of America by Versa Press, Inc.

Distributed by Publishers Group West

First Edition

Portions of this book first appeared in the *Nation* magazine; *The Coming White Minority: California, Multiculturalism, and the Nation's Future*, by Dale Maharidge (Vintage Books); *Someplace Like America: Tales from the New Great Depression*, by Dale Maharidge and Michael S. Williamson (University of California Press); The *Sacramento Bee*; The *New York Times*. All photographs courtesy of the author with the exception of Terrance Roberts, photos courtesy of pp. 98-99; p. 125, courtesy of Nathan Mahrt; p.30 by Dorothea Lange, courtesy of the U.S. Farm Security Administration/Office of War Information, Prints & Photographs Division, Library of Congress, LC-USF34-009916-E. Funding was provided by the Economic Hardship Reporting Project.

CONTENTS

For Joanne

Fucked at Birth

FUCKED AT BIRTH

From March through June of that darkest of years—more bleak than my youth of 1968, when Bobby and Martin and so many dreams died—I was living in Southern California near the beach. We all have our pandemic stories. Mine was quite uncommon in that I was one of those relatively few Americans afforded the luxury of working from home on Zoom. I didn't have to gig hustle for Uber, Lyft, or DoorDash, or drive for FedEx, Amazon, or UPS—or worse, pray that my job came back after the temporary assistance ran out. We with white-collar employment make the assumption that a majority of Americans are exactly like us because most of us never interact with the working class. A friend who was well intentioned, yet clueless as to how most of the three hundred million or so of our fellow citizens live, suggested that to survive a crisis such as Covid-19, Americans should have $5,000 cash on hand, or double that amount if our budgets could afford it. A year before she uttered these words to a journalist for a major publication, the Fed reported that, in the best economy in postwar history, four out of ten Americans did not have enough money in the bank to "pay an unexpected expenditure of $400.19."

I was in New York City earlier that year, teaching my classes. In late February, I'd fallen ill—there were intense headaches and I was sleeping long, fitful hours—then it became difficult to sit in a chair. My lower back hurt. I assumed I had pulled something, but later suspected it was a kidney infection. I'd been around two sick people. I didn't believe that it was the novel coronavirus

because federal officials asserted that it was not yet in the United States. (Much later, in California, when I had an antibody test, the first one showed that I was possibly positive but a second came back negative. The test cost $50. Most of the dozens then being peddled were unreliable.) I told myself I had it. But maybe I didn't.

We were without national leadership. It was the quintessential American story: we were left to fend for ourselves. We were told masks were worthless. Then we were told they were necessary. In Manhattan, store shelves were stripped of hand sanitizer and alcohol. In high school my friends and I found a way to purchase 190-proof Everclear. Our motto: "Things are never clear with Everclear." Was it still sold? I found the last two flasks available at a liquor store on Broadway and thereafter reflexively doused my hands from a small yellow spray bottle of it that I carried everywhere.

After recovering from the illness, I chose to remain in the city, even after we were compelled to switch to online teaching. The streets were largely deserted. The panhandlers remained visible. A legless beggar without a wheelchair always sat on the sidewalk at the West Side Market near my apartment, his hand out. With far fewer customers emerging, this man grew desperate. He now lunged, crawling toward me like a skittering crab, propelling himself with the stumps of his legs and one arm, the other arm outstretched, palm extended; his eyes were feral and pleading, and from his gaping mouth hung a sliver of drool. The next evening I was at JFK, sending pictures of the unpeopled JetBlue terminal to friends. On a call to one of them I resorted to cliché: *It's a scene out of a zombie apocalypse film.* Or was it simply reality? There were twenty-eight people on the flight to California.

For the next two months I isolated with friends, working in a cottage in their backyard. We kept to ourselves like many white-collar Americans. We watched from the window as the delivery

drivers from Amazon, UPS, and FedEx left a steady flow of boxes on the front porch. We did not interact with them.

Late on the morning of Tuesday, May 26 Pacific Daylight, the *New York Times* informed me as I drank coffee that the U.S. Department of Labor reported 3.3 million Americans applied for unemployment benefits the previous week, a record, and that the markets back east were roaring. The Dow was up three hundred points and the S&P would hit an eleven-week high. Bloomberg wrote that "stocks had soared earlier as investors poured back into risk assets on speculation the worst of the economic hit from the pandemic has passed."

It was garbage day. I left the cottage and went to fetch the wheeled black plastic barrel at the bottom of the drive. When I turned the corner of the house and started downhill toward the street, I noticed a man and a woman at the bright blue recycling container, which had not yet been emptied by the city truck. When they looked up, guilt filled their faces. They did not belong in this scene. They were too clean-cut. "I never thought I'd go through trash cans for money," Rudy Rico told me. "But you got to eat."

A mockingbird in a nearby Queen palm filled the ensuing silence. Rudy was a landscaper until he was laid off because of the pandemic.

"We were staying with my sister, but she got the bad liver, and the doctor told her she had to get everybody out of the house," Rudy said.

Rudy and his wife, Christina, faced a choice while they waited for the unemployment benefits that were slow in coming: keep money from it when it arrived to eventually catch up on rent, which had been suspended due to the pandemic, or make the car payment. They chose the car, which was now their home. It was parked up the street. They told me they slept on different streets

each night to avoid the cops and they preferred being near the public restrooms found at the beach.

A trove of soda and beer cans and bottles was amid the cardboard from all of our delivery boxes that I'd cut up and stuffed into the barrel. "Right here is probably like $3," Rudy said. We were a good score—they earned only about $50 per long day of rummaging in barrels. "I don't want to have anything for nothing. I'd rather just get cans," Rudy said. He patted his pocket where his unemployment check was stashed, "But [this is] going to save the car." The couple, both fifty-five and married for thirty-seven years, said that they will likely be homeless for a long while even when Rudy returned to work. "It'll cost $3,000 to get back into an apartment," Rudy said.

Christina thought I'd come down the drive to admonish them like some rich people had done.

"Some people get angry," she said.

We create ever-changing narratives of our lives as we age. It isn't that we are selling ourselves to others in the manner of politicians manufacturing crafted public narratives—we sell ourselves to ourselves, to cope with and make sense of things as we move through our decades. There is the narrative of my Ohio childhood: my raging war-ravaged father, his dream of being his own boss and having money; in our basement he grinds steel tools on massive iron machines, a side business he does at night after his day job in a distant factory; as a prepubescent child I begin grinding with him. Dad is almost killed after being hit by a drunk driver and he cannot work for months; I am not old or skilled enough as a machinist to save the business; and my mother, who drives a school bus, feeds our family with charity food from the church. In this narrative I live in fear that I will grow up to be a blue-collar worker, facing all the precarity that comes with this existence.

The narrative of my early twenties: I now call myself a writer; I ride my Yamaha motorcycle, in rain and sleet, around a thirty-mile semicircle swath of suburbs, covering school boards and city council meetings as a stringer for the Cleveland newspapers, trying to write my way out of the factories. I also work at Plastic Fabrication, Inc., operating a lathe, churning out industrial bearing spacers; I am not a writer, I am lying by calling myself one—I'm an impostor despite the growing number of bylines in the *Cleveland Plain Dealer* and other newspapers. I drive west in 1980 and live out of my Datsun pickup, cold-calling newsrooms; months pass and I am not being hired; I am now simply homeless. My narrative suddenly changes when I land a job at the big newspaper in Sacramento. In my late twenties I become the "blue-collar" writer, as one editor dubs me; I own the appellation.

Midlife narrative: I'm shaking hands with Kenny Rogers onstage at Carnegie Hall in New York; talking with Jimmy Carter in Nashville; lunching with an assortment of names: John Kenneth Galbraith at the Harvard Faculty Club, Billy Friedkin in Beverly Hills, Roger Strauss in New York; chatting with Jerry Brown at his Oakland commune before he interviews me for his radio show; sneaking into an abandoned steel mill with Bruce Springsteen in Youngstown, hoping the guards don't catch us and have us thrown in jail; dining with other names: Tom Wolfe when we brought him to teach at Stanford, Bruce Cockburn in New York, Studs Terkel in Chicago. I'm standing next to Beck backstage in Mountain View, at the Shoreline, after Chrissie Hynde ran out of her dressing room and slammed into me by accident, nearly bowling me over. I'm at an Upper East Side literary party where I meet George Stephanopoulos, Alice Mayhew, Carl Bernstein, Ken Auletta, and Charlie Rose, who grabbed the ass of the woman I arrived with; I don't really know most of these people with the exception of Bruce and Studs, and will never see most of them again; I am a distinguished visiting professor at Stanford, later a full tenured professor at Columbia. I am physically present but I

do not comfortably fit with any of the titles or scenes, and in fact I am quite uncomfortable with them. I'm no longer the blue-collar kid or the blue-collar writer. Nor am I the Ivy League professor, though this is now my operative public narrative. In the private realm I remain an impostor—in all worlds. I belong nowhere.

I think of what Borges said in an interview about memory, something his father told him:

"...If today I look back on this morning, then I get an image of what I saw this morning. But if tonight, I'm thinking back on this morning, then what I'm really recalling is not the first image, but the first image in memory..." And then he illustrated that, with a pile of coins. He piled one coin on top of the other and said, "Well, now this first coin, the bottom coin, this would be the first image, for example, of the house of my childhood. Now this second would be a memory I had of that house when I went to Buenos Aires. Then the third one another memory and so on...in every memory there's a slight distortion..."

Our narratives are like those coins stacked on a table. We create and re-create them so many times that the top coin is a specious definition of our lives. What are we, really, by our sixtieth year? In meeting Rudy and Christina that morning, so far from my youth in Cleveland, something in me swept away the top stack of coins and there was a glimpse, however fleeting, of the first coin on the table. That evening in San Diego I kept replaying the digital recording I made of the interview with them. I lay in bed thinking about the couple; they reminded me of the working-class people I grew up with.

There was no end game. We would flatten the curve and buy the federal authorities time to make a plan. But the authorities never made a plan. We were supposed to isolate, but for how long? One year? Two years? We wondered what the rules were in this new paradigm of the ongoing zombie film. Was it okay to have fun?

The day after meeting Rudy and Christina, I went to the desert with a friend. She drove us away from the coast and into barren, dun-colored mountains, where roadside signs were riddled with bullet holes. We descended to a dry valley floor dotted with creosote bushes. A resort built in the 1930s appeared in the distance, marked like an oasis by a cluster of towering California fan palms and old-growth tamarisk. It was one of those weird desert places that actor, playwright, and director Sam Shepard would have loved, and it was made even more surreal when we checked in with the masked desk clerk, while another masked worker who never spoke came up from the side and zapped my forehead with the light of a thermometer. Only a few of the many red-tile-roofed *casitas* appeared to be booked—I only saw one other couple walking across the grounds—but we wore our masks and I liberally used the spray bottle of Everclear. We had the capacious blue swimming pool beneath an even bluer sky to ourselves that afternoon and the next morning. We were utterly alone. We took off the masks and bounced an inflated ball back and forth in the shallow end. When we drove out at noon, there was an abandoned gas station that caught our eyes because of the faded American flag painted on the front.

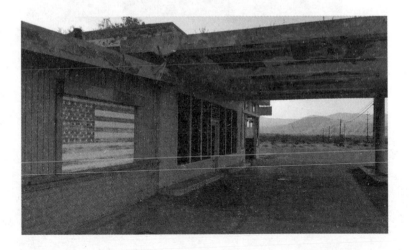

My friend asked if we should stop. *Nah, the light's too hot to make a good picture.* A good picture required evening light or, better, the first rays of sun because the flag faced east. As she made the turn and began speeding up, I thought, *To hell with the light.* I said: *Stop.* She pulled to the shoulder. The slamming car doors were sharp in the desert air. We stood and looked at the building that I'm certain Walker Evans would have photographed, as would my longtime collaborator Michael S. Williamson. When we went through the front door we faced this graffito painted on a sheet of plywood partially covering a rear window.

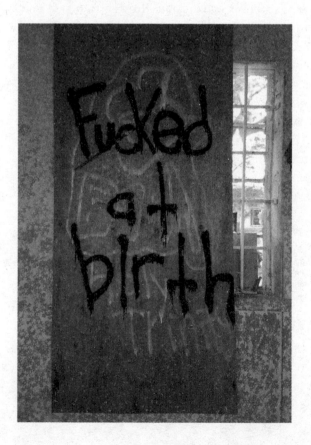

LOAVES & FISHES

I've had two breakdowns. The first happened in 1983 and the second in 1985, and each in part was attributable to a long run of getting close to people like the person who I imagine wrote that scrawl inside the abandoned service station. The 1985 breakdown happened after I finished *Journey to Nowhere*, a book in which Michael and I rode the rails with new hobos for a few years. We began that project in Youngstown, Ohio, chronicling the death of the steel industry, the jobless workers who set forth seeking work, and ended up hoeing sugar beets with them in California's Central Valley. I was living in Sacramento when I finished writing. This was before the internet and email. After working all night, I drove to Federal Express (not yet FedEx) that morning to ship a hard copy of the final manuscript. On the way home I passed a brand-new nonprofit called Loaves & Fishes that had a small soup kitchen for the homeless and a courtyard meeting area. There was a long line of mostly men standing along Twelfth Street, waiting for a meal. As I drove past, looking into their eyes, I began weeping. The ensuing weeks were desolate. I didn't see a shrink. But when frightfully painful stomach cramps began doubling me over at night, I went to a physician, who said the attacks were a result of stress and PTSD. These details have appeared elsewhere in my writing and aren't needed here, except to say the 1980s led to my pretty much withdrawing from society in the 1990s, living literally off the grid, in a rural solar-powered house I built myself over a half mile from my nearest neighbor. I returned to

writing about the growing number of people left behind as the 1 percent amassed more and more wealth. Finally, in December 2016, I published a twenty-one-page spread in *Smithsonian* about the sweep of American poverty in a nation that was supposedly in economic recovery. I told all of my friends that was the last time I'd do this kind of work. I had nothing else to say.

Then I met Rudy and Christina and went inside the abandoned service station out in the desert. I couldn't stop thinking about the couple and the words spray-painted on the plywood. One night I studied the photograph, blowing it up on the television screen I used as a monitor in the cottage. I also looked at other graffiti—mundane scrawls about weed or people's names and love interests—that I'd photographed in the building. They were different colors. The author of FUCKED AT BIRTH chose black, the perfect hue, and this person held the aerosol can close to the wood and applied the paint slowly enough so that it ran and formed drips. There was a level of emphasis. I felt this person's anguish. How was it they were fucked at birth? The manifestation of this curse has numerous causes, I have learned over the decades in talking with many hundreds of Americans experiencing hard times. There are the demonstrably fucked at birth: Those born to mothers addicted to opioids or with fetal alcohol syndrome. Those born into poverty. Those fucked at birth because of the color of their skin. There are the unwitting fucked at birth: they believed their job would always be there because it was there for their parents and grandparents, and then the corporation announced the job was going to China or Mexico, and being on the other side of forty-five and only having a high school diploma, there was no level of retraining that could save them.

There are those fucked at birth only due to the timing of their arrival into this life. I was born in an era when the son of a blue-collar steelworker could fuck up as much as I did, such as not finishing college, and still pull off leaping up in class. I bought my first house—a three-bedroom ranch on almost a half acre in one

of the best suburbs, at the age of twenty-four in 1982 for $70,000, about three times my annual newspaperman's salary. This was possible for two critical reasons. I was white and not Black. And my emergence as an adult came at a rare point in history, the few decades when the children of the working class could catapult out. The United States composed about three-fourths of the world's economic power, the resulting spoils of World War II. Today we are about 24 percent of the world's economy, according to the International Monetary Fund. Economists say this is still a bit higher than our expected portion. It was inevitable that we would fall from that midcentury peak, but what was not inevitable was allowing the 1 percent to amass so much of the economic pie.

Being born into the working class in the 2020s is pretty much a guarantee of never having upward social mobility. *Ergo: Fucked at birth.* Even before the pandemic economy, many of my students at Columbia university were having great difficulty finding jobs that paid well enough to survive, and the work they had was often temporary. They were not so much swinging from vine to vine between jobs—it was more like they were grabbing at threads of dental floss.

A decade ago Michael and I published *Someplace Like America: Tales from the New Great Depression*. It was a quarter-century reportorial retrospective on our work. I thought there would be pushback from some reviewers on the subtitle, but it was not disputed. For the two-thirds of Americans whose income has been stagnant or fallen, it's simply a truth. It's unclear at this point if the economic downturn will be something like I covered in 1982—a severe recession—or if it will be officially labeled something far worse, this century's Great Depression. But already the virus has unmasked the reality of our subtitle. We have long been unofficially in this realm.

In the early 1980s, I thought simple awareness would instigate political and social change. All that was necessary was to document what was happening. Our *Journey to Nowhere* in early 1985 was

the first book on the "new" homeless and growing inequality. Dozens of other books were soon published, and in the coming decades, the tally would be in the hundreds. Many are similar, including ours, in that they all sound like a version of the same tired country ballad playing in a honky-tonk where everyone is drunk and not listening to the music. For a time, I thought I was done with the work, at least the way in which I'd conducted it, with methodical research and the patient telling of the stories of a wide range of Americans. Then I went to the desert and we discovered the graffito. It was time to change the song.

I returned to the desert a few weeks later. I arrived at the abandoned service station in the early afternoon, when the light was yet too hot for a proper picture. I wanted the extra time anyway. Over the years Michael and I have explored a lot of ruins—dead steel mills and factories in the Rust Belt, abandoned farms on the High Plains, rotting sharecropper shacks and plantation mansions in the Deep South—and we believe that it's necessary to make peace with the troubled spirits that occupy these ghost places. Otherwise it feels like sacrilege. I thought of the past four decades as I meditated in the silence, which was broken occasionally by a car accelerating from a nearby stop sign. I worried someone would admonish me. But no one cared that I was there the entire afternoon. I wondered: Did I find this ruin, or did it find me? Often the path of life delivers us to the places and messages we need to see. I remained until the sun set and the desert dusk equalized the light. I took pictures.

The economy was already being characterized as in a "pandemic depression" by economists Carmen Reinhart and Vincent Reinhart, in an issue of *Foreign Affairs* about to come off the presses. Here, at the beginning of this journey, I felt how I would imagine it would have been like to head out into the late winter in America of 1929.

II

CALIFORNIA

THE SNAKE PIT

I had to return to New York City. I planned on driving; flying seemed a terrible notion. I'd car camp, hike in the slickrock canyons of the Colorado Plateau, see a few friends along the way. In a period of a few days, after meeting Rudy and Christina and finding the abandoned gas station, that initial plan was jettisoned. Instead, I pitched my editor at the *Nation* to do a story about America in this fragile moment. The graffito pushed me over the edge—it transformed the journey into a mission. I teach my journalism students to have a "central question," a term used in academic sociological research but fits the goal of narrative storytelling. This central question is something that needs to be answered—otherwise there is no story. "Fucked at birth" would be my central question. Everyone I met would be shown the photographs on my smartphone of the exterior of the service station with the worn painting of the American flag, and of the words spray-painted inside. Their reactions would be a Rorschach test of sorts. There was a whole country of struggling people who might or might not relate to those words. I had no idea what I'd hear.

Starting the work meant going to Sacramento, a town that is much more than a city where I once lived. It entailed returning to an earlier narrative of my life, the homeless aspiring writer, which meant facing a lot of darkness. As I drove north on interstate 5 through the Central Valley, I recalled the early days. After living out of the Datsun pickup for months, I finally had promising news.

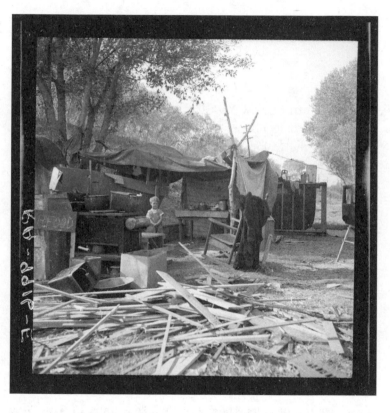

American River camp north of downtown Sacramento, 1936.
(Photograph by Dorothea Lange, U.S. Farm Security Administration.)

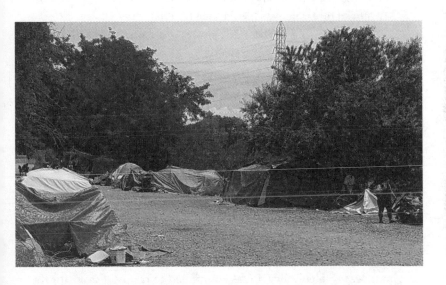

American River camp north of downtown Sacramento, 2020.

City editor Robert Forsyth at the *Sacramento Bee* told me by phone that he might have an opening. He said things could fall apart and that I shouldn't set my level of hope too high. He'd have a definitive answer for me the day after the election. I splurged and paid for a camping spot at Doheny State Beach in Southern California and walked the tide line to burn off tension. I was nervous when I went to a pay phone that Wednesday morning. "I have good news and bad news," Bob said. I wanted the bad first. "Reagan is president." My official hire date was November 17, 1980.

I moved into a brand-new apartment complex north of the American River, surrounded by fields of safflower and other crops. It was one of the first developments in what was then an extensive agricultural area. After work I sometimes walked south into Discovery Park, where the American, descending from the gold rush hills of the Sierra Nevada, empties into the Sacramento River. There was a riparian forest and tangles of wild grape that formed near-impenetrable thickets. Occasional trails led into this brush, and at their conclusion I found sheets of cardboard or newspapers set on the ground, where people had slept. I wondered who they were. Undocumented immigrants? Or what we still then called "winos"? I grew up working class but understood absolutely nothing about the homeless or alcoholics. I was compelled to report a story for the newspaper, which ran on January 17, 1981. I spent a few days and nights hanging around the Volunteers of America Drop-In Center, commonly known as the detox center. When they didn't crash there, they slept "in the weeds," as they called it, in those bivouac sites. When they were picked up by the cops and brought to the center, they flopped on one of sixty mattresses set in rows on a concrete floor. There were no women in this scene. It was essentially a warehouse for society's cast-off men, but some were being rehabilitated. Officials told me there were nine hundred "hard-core" regulars. *It's a brutal lifestyle, where 30-year-old men look old, and those over 60 look deathly,* I wrote. *It's an ocean*

of unconscious bodies in twisted positions. The air is steamy, smelling of sweat, wine, vomit and sterilizing solution. Reading the article now, I sound wide-eyed and young. That's because I was. The scene and my view of it radically changed by 1982. There was an influx of new homeless, people who never before had lived on the street, casualties of the recession that was then raging.

I can mark with precision the week that more homeless people began camping along the river. By the spring of 1982, a tent city had emerged on Bannon Street, across from a rescue mission. In the first week of June, they were evicted. I wrote about it for the newspaper, in a piece that was published on June 13, 1982:

> Four months ago, Ron Blair was laid off and had no place to call home. So while looking for work, he began camping at the Bannon Street mission operated by the Volunteers of America.
>
> About one week ago, he lost even that meager home.
>
> The campground in a field behind the mission was fenced off and closed, the victim of budget cuts and a desire by the city of Sacramento to put a maintenance building on the grounds.
>
> Accompanying the closing was a corresponding increase in the number of persons camping in Discovery Park and along the banks of the American River, much to the annoyance of Sacramento police who have been rousting them over the past week.
>
> "They want us to get out of this town," said Blair. "I've paid taxes all my life. Most guys here work every day. Why treat us like dogs?"...

In the ensuing years, "poverty" became my beat. I remained in Sacramento through the 1980s, documenting hunger and homelessness for the newspaper. By the end of the decade there

was a police team known as "Bronco Billy" that hounded the homeless. Late one afternoon, the phone rang at my desk. A gruff male voice told me the cops were going to bust the homeless the next morning. *Be at the river, under the Sixteenth Street Bridge, at six thirty.* Click. I documented the police sweeping the people who lived there, hauling away their belongings.

I left the newspaper in 1991. When I came back to town in 2009 to report on a book, authorities had just closed down a big tent city after it appeared on *The Oprah Winfrey Show*; politicians cited "health and safety concerns" and not embarrassment at the publicity. Civil rights attorney Mark Merin was fighting for "Safe Ground," a legal place for the homeless to camp, and I tagged along on a protest march that afternoon. Sacramento officials were opposed, continuing their long-standing hostility toward the homeless. Then, eleven years later, I returned on the very day when Merin was holding a press conference to announce, in part due to the virus, finally winning the right to create Safe Ground.

Things were different, to be sure. Except for the speakers, everyone at the presser wore masks. Even with his face covered, because of his wiry gray beard and gray ponytail, I recognized John Kraintz, a homeless man I'd first met a decade earlier. He was now in an apartment but still doing activism for the homeless. He was the first person I showed the pictures of the American flag on the gas station and the writing inside, and when he looked up from my phone he quickly responded, "In the Declaration of Independence, they said all men are created equal. That was the first big lie. If you've got money, they care about you. It's all about money."

I'd come to the presser with Joe Smith, advocacy director for Sacramento Loaves & Fishes. His job was to immerse among the homeless, to help them get services. We'd first talked on the phone days earlier. He told me that since the start of the pandemic, homeless people had poured into Sacramento from surrounding counties. He said I wouldn't recognize the situation

along the American River, not far from where I'd once lived. There was now a camp off Sixteenth Street called the "Snake Pit." *There are hundreds of people in there. It's come to the point where the camps have kind of developed like cities, you have a downtown part of the camp area, and you have little areas off to the side where there'll be eight or nine tents — they're kinda like subdivisions.* He said the official count was some 5,500 homeless, but in reality it was more like 10,000.

After the press conference, we stopped at Loaves & Fishes, now sprawling over five acres in an industrial area north of downtown, and it had the feel of a homeless-industrial complex. There was a school for homeless kids, a safe house and residence for women, a mental health clinic, among other services. The nonprofit is proud that it takes in no government funds—it doesn't want to be told what to do. In 2019 it spent $7.4 million from donations and had 80 employees: that year it served 136,384 meals and 152,400 cups of coffee, provided more than 30,350 hot showers and shaves, and distributed over 47 tons of food that passed through its warehouse.

An unseen woman screamed "Help me! Help me!" over and over. I learned this woman always screamed. It concerned me, but no one paid her any mind—it was something she always did—and there was no time to go investigate. The vast scope of the trauma must be let go if you are to face it, otherwise the trauma becomes your own. It is something I've come to cope with but never gotten used to.

We drove off to visit the Snake Pit. I reeled from the number of tents and shelters stretching into the forest and meadows on either side of the levee as we walked along the river. There were many dozens of elaborate camps. Joe pointed to the right, beyond feral almond trees heavy with immature nuts, to thinly spaced trees amid golden patches of Russian thistle and meadow grass. "This area? Just going that way there's probably five hundred people buried in there." These were not temporary

accommodations. They reminded me of the images Dorothea Lange took of homeless camps along the American River in late 1936 for the U.S. Farm Security Administration. I never could identify the precise spots—her notes were not that detailed—but using the levee in her photographs as a guide, we clearly were passing those exact sites nearly eighty-four years later.

There was a racial mix in the Snake Pit, with whites and blacks dominating. I met a lot of people, among them George, an African American man who came here from Oakland, and the two of us walked down the levee bank to his tent, where he showed me his 100-watts of solar panels and a 1,000-watt AC inverter next to a 12-volt DC battery. The setup powered lights and a television, and he charged the phones of many of those living around him. George, in his late thirties, then pulled out a scrapbook of his family, filled with pictures of happy times. There was an image of his recently deceased mother. He began sobbing. When we ascended the levee bank, Joe was talking to a white woman who lived here. I asked why it's called the Snake Pit.

"There's a bunch of snakes here," the woman said.

"And they're not cold-blooded creatures," George said.

"There are some snakes here that live on the ground, but most of them walk on two feet," the woman added.

We walked on, following a road on top of the levee. Joe said he's bracing for an onslaught of new homeless as the economy worsens, and people who have permanently lost jobs due to the pandemic are evicted from apartments. "It's really scary for a couple of reasons. There's a whole new segment of people that are going to go from being housed to unhoused, and it's going to happen suddenly. It's going to be very traumatic for them—you just lost your world. They can react one of two ways. They can be scared and dysfunctional. Or they can come out here and just be as brutal as they can be, you know, their survival instinct. Going to be one extreme or the other. And I know this because I did this. I was that person..."

He trailed off. The river was a little bit hairy back in the 1980s, but the level of desperation had exponentially increased. It now felt a *lot* hairy. I suddenly was glad I had Joe as my docent.

"And they're also going to be carrying everything they can from their previous home, and these guys out here, there's a lot of predator-type behavior, especially once it gets dark. They will take your stuff, if anything, to assert their dominance." He likened the coming crisis to a Midwest thunderstorm. "By the time it gets on top of you, the world is ending, and then all of a sudden, *boom*, you know, you're left with the aftermath." He said new people won't immediately end up living in tents here on the river. The journey into abject poverty is a process. "You're gonna try to hang on to the car. Of course, hang on to valuable stuff, which makes you even more of a person of interest to somebody who's looking to capitalize on your misfortune. It's just an incredibly dangerous time, that initial moment of homelessness."

Some will run out of money, the car will break down, and they won't be able to afford fixing it. They'll resort to living beneath tarps. I'd seen this repeatedly in my reporting over the years. I knew the process. Once the car is gone, the descent into the madness of homelessness happens fast. If you don't start out mentally ill, there's a good chance you'll end up that way. I wondered about Rudy and Christina—would they be able to get back into an apartment?

We visited over a half dozen camps and talked with residents. Joe complained about the police. There was a county health order mandating that the homeless not be moved to prevent the spread of Covid. But Sacramento County Park police were circumventing it by citing the homeless for other infractions.

As we walked by a camp next to a paved bike trail, Joe told me one resident, Pike Stolz, had three citations—one for tying a rope to a tree to hold up his tent. He had not damaged the tree. On our return, when we rounded a bend, it was as if Joe conjured the cops. An enforcement team was at the camp giving Pike a hard time.

ORDER OF THE HEALTH OFFICER OF THE COUNTY OF SACRAMENTO DIRECTING ALL
INDIVIDUALS LIVING IN THE COUNTY TO CONTINUE TO STAY AT HOME OR AT THEIR PLACE OF
RESIDENCE, RECOMMEND WEARING FACE COVERINGS AND RELAXING RESTRICTIONS ON
LOW-RISK BUSINESSES CONSISTENT WITH DIRECTION
FROM THE STATE OF CALIFORNIA DATE OF ORDER:

May 22, 2020 UNDER THE AUTHORITY OF CALIFORNIA HEALTH AND SAFETY CODE SECTIONS
101040, 101085, AND 120175,
THE HEALTH OFFICER OF THE COUNTY OF SACRAMENTO ORDERS:

Homeless Encampments

CDC guidance for those experiencing homelessness outside of shelters is to be
strictly followed. To maintain public health and safety, allow people who are living
unsheltered, in cars, RV's, and trailers, or in encampments to remain where they
are, unless the people living in those locations are provided with a) real-time access
to individual rooms or housing units for households, with appropriate
accommodations including for disabilities, and b) a clear plan to safely transport
those households. Do not cite, clear, or relocate encampments, or cars, RV's, and
trailers used as shelter during community spread of COVID-19. Do not remove
property from people experiencing homelessness, which includes their shelter
(e.g., tents, vehicles, or other living structures), hygiene equipment, food supplies,
water, and personal items. Items that people who are living unsheltered designate
as trash and request to be removed can be disposed of. Clearing encampments
causes people to disperse throughout the community and break connections with
service providers, increasing the potential for infectious disease spread. Exceptions
are encampments that pose an imminent and significant public safety hazard, such
as a large excavated area of a levee.

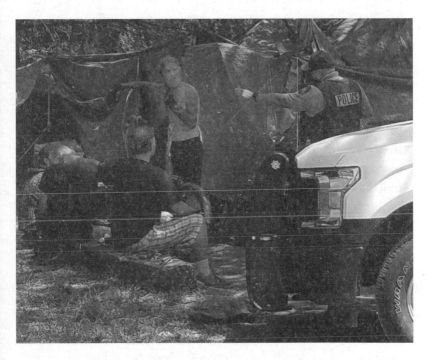

The cop, pointing at Pike Stolz.

"What are they doing?" I asked.

"We'll find out."

I started to cross the street but Joe wisely halted me: "Let's walk to the stop sign. To be a disrupter, you have to follow the letter of the law."

We legally crossed the road and approached, but officer M. Piazza, badge number R71, ordered us to fall back. We sat about a hundred feet away. Joe said just one of Pike's tickets would cost him $480. Another man from the camp was handcuffed inside the SUV cruiser, rage in his eyes. Joe told me he'd murdered someone long ago at Loaves & Fishes and spent time in state prison. He was on parole. Joe theorized that the cops were hassling this camp because it was so visible, next to a bike trail. Spandex-clad people on thousand-dollar bikes sped past. After Pike was cited and the cops continued occupying his camp, he crossed the bike path. He showed me the ticket he'd just been given, the fourth citation in the past week—this one for riding his motorized bicycle across the bike trail. I asked why they created the camp so close to where the cops could mess with them. Pike, fifty-two, pointed to a street-lamp that I had not noticed. He wanted to sleep beneath the bright light at night because it made him feel safe. He was afraid to jungle up back in the thickets of wild grape where the two-legged snakes could attack at dark.

I pulled my phone out and showed Pike the pictures from the desert. He pointed to the man still handcuffed in the cruiser and said "fucked at birth" certainly applied to him. "[He's] never seen a day in his life of happiness or hope—nothing but jails, institutions, and stuff like that for him. But I don't feel like I'm fucked at birth. I feel like some of it's my fault right now." George, who had the solar panels, also blamed himself, as did others I met in the camps. Pike told me he'd served in the U.S. Coast Guard and it bothered him when one of the cops said, "We're taking our park back." "When you hear a ranger tell you we're gonna be taking our park back, he's thinking it's his. I'm not an American now? We have lost the continuity we have between people."

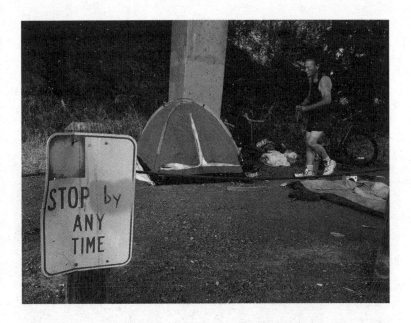

There were two other major homeless camps in town, one in south Sacramento, the other to the northwest on the Sacramento River, known as the "Island." This encampment drew an older crowd that even before Covid had isolated itself to keep the residents safe. Now with the pandemic, they were even more closed off. "They're dug in. It's beautiful back there. Absolutely beautiful, a massive encampment." Joe compared it to an "affluent calm suburb." The leader of the Island was a woman named Twana James. I would have to pass muster with her before I would be allowed to visit tomorrow. Joe gave me her cell phone number.

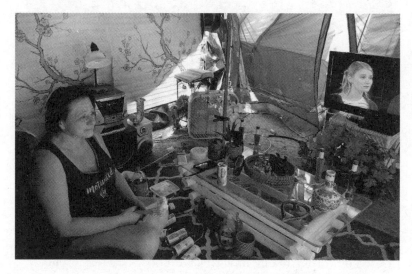

Twana James's home at the Island. Almost everything in this picture—the television, stereo, and other items—came from trash bins.

THE ISLAND

I followed Joe Smith down a well-traveled trail flanked by box elder, tangles of wild grape laden with bunches of green fruit the size of BBs, and plentiful poison oak. We emerged in an open forest. The broad Sacramento River glistened in the noon sun through gaps between the trunks. At the brink of the bank was a graveyard for the dogs of the Island. Crosses marked the resting spots for Yogi, Girl-Friend, and Ginger, among others. DOG BLESS was written on two crosses.

Twana, fifty, agreed to meet after a conversation by phone the previous evening. She is an upbeat woman who doesn't like calling herself the leader of the Island, but by default she owns this title because she's driven by love to help the residents. Her accent is typical of working-class and poor whites in the Central Valley—words fall off, she speaks fast, in a mumble. I've always wondered if this is a linguistic legacy of the dust bowl migration. "We have movie nights. This Saturday we're going to have *Passion of Christ* for people who haven't watched it. I have Bible study on Wednesdays and Saturdays from eight to nine." She loans books from a small library in her tent. She cooks. Tonight's menu: "pigs in the blankets" that she'd prepare for about thirty-five of the seventy residents of the Island. Rolls of biscuit dough at her feet would be used to wrap hot dogs, and then baked. Members of the Island pitch in money and she seeks donations on a GoFundMe page, but often Twana spends her food stamp allotment, as well as part of her Supplemental Security Income check, to cook for

everyone. "I end up spending it helping the guys, and the elders 'cause I love 'em. I do." She came to tears as she talked about a man named Renegade. "He's getting up there. He can't walk; he can't make it to the bathroom sometimes. He makes a mess, you know..." Another man was blind.

"We take care of our own," Twana said. "We take care of the elders. I was paying to have water brought to old people." Today Joe came with cases of water, and a younger resident brought it to the camp in a wheelbarrow. I asked the cost for feeding her neighbors pigs in the blankets. "With cookies and something to drink—Kool-Aid—that's like sixty to seventy bucks," which comes out to about $2 per person. The camp was a stark contrast to the Snake Pit. It was clean, the ground swept free of debris. As we spoke a neighbor came to borrow Twana's leaf rake. Her home was tidy. Almost everything— a tiny Jesus, a purple glass heart, television, stereo, and fan—came from dumpsters. Her brother gave her the table and a few other items.

As Twana talked about how the community functioned, I thought of it as a cooperative (or, as Joe calls it, a "collective"), and I flashed on Tom Collins's New Deal Works Progress Administration camp in Weedpatch, south of Bakersfield, which was depicted in John Steinbeck's *The Grapes of Wrath*. That camp practiced self-governance, in the true definition of the word "anarchy," which has nothing to do with violence. It was pretty much the same at the Island. There were rules and scofflaws were evicted. They didn't want to give the cops any excuse to invade. Twana and the others had brought order to their lives that otherwise had no order.

I was looking at the future. In a year or two, a large number of Americans would lose their apartments and homes in the economic fallout of the pandemic. Rudy and Christina were early adopters of sorts for a coming unprecedented wave of homelessness. "In the absence of robust and swift intervention, an estimated 30–40 million people in America could be at risk of

eviction in the next several months," according to a white paper by a consortium of housing rights groups and advocates, including the Eviction Lab at Princeton University, the Aspen Institute, the Covid-19 Eviction Defense Project, and the National Low Incoming Housing Coalition. "The United States may be facing the most severe housing crisis in its history...Black and Latinx people...constitute approximately 80% of people facing eviction."

Most of the 30 to 40 million wouldn't become permanently homeless, but any percentage of that estimate that did is a staggering number. I have no faith the government will be there to help them, given the past four decades of American political life. They're going to be on their own to make do, creating their own collectives hidden in the woods, just like Twana and her neighbors. The only question that remains is what the modern-day Hoovervilles will be called—Trumptowns or Bidenvilles, if the Dems in victory do nothing to help.

I showed Joe the pictures.

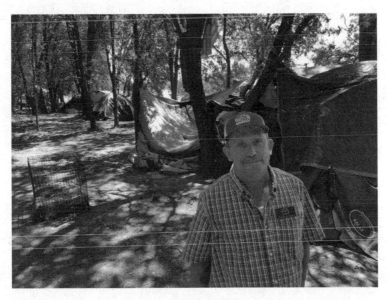

Joe Smith at the Island.

"I understand it. I've felt it. Oh, I have felt it. You know, when you start to look back at your life and you're sitting at a different stage, I look back at where I've been, and the view is different. 'Fucked at birth' wouldn't be the thing I would say now. In 2010? Sure.

"Sometimes we get wisdom from what happened and other times we get bitter about what happened. I get that. You're just standing there with a friggin' spray can in your hand and you're screaming in your head and it just—that's what ends up hitting the plywood. Whatever was in here is gonna come out there. It always comes out."

In 2010 Joe had hit bottom. In a twist of life circling back, how some stories never really end, he wound up at the same organization I wrote about in 1981 when I first came to Sacramento. "In 2011 I got put into the VOA sober-up house, they call it a 'detox.' It's a place to go dry out. I got sober. It took me about five years to rehabilitate. My liver was all shot." Joe's lived it. "There's a lot of trauma naturally that comes along with being out here." He means today and not one decade ago. He still imagines where he'd hole up to be safe. When we were walking along the levee at the Snake Pit the previous day, he pointed to the bank of the American River. "I look at that spot over there...that tree. I start to see my camp form in my head. I have incredible PTSD. For me to stay outside, I would be in a ball rocking back and forth all night long."

In 2016 he was hired by Loaves & Fishes after he spent time volunteering to clean up. "I started out as a part-time janitor, part-time street monitor, full-time street monitor, and then the assistant director of Friendship Park." Now he had his present job. "It felt like forever," he said of life in the weeds. "So I'm kind of in a unique position to be the advocacy director. I'm not your policy writer. I'm the advocacy director of experience. I understand this in a way that other people don't, and that's a superpower, man. We got to use our superpower when we figure out what it is."

After leaving the Island, Joe drove me back to Loaves & Fishes. The unseen woman was screaming "Help me! Help me!" Before I got in my car to point it south down the 5 toward Los Angeles, I asked again about the wave of newtimers he sees coming.

"There's nothing we can do to plan for it," he said. "We have capacity to step it up, if we need to feed another five hundred people. There's different logistical aspects, like money and delivery of food, but the actual 'make the meals' kind of thing? Piece of cake."

"What if it's two thousand, or three thousand?" I asked.

"No problem."

"Really?"

"No one will walk away."

GRIFFITH PARK

If the Great Depression conjures up images of shanty towns (Hoovervilles) and endless breadlines, and if the Great Recession is associated with the hollowing-out of cities and neighborhoods through foreclosure, then what is the face of the COVID-19 pandemic? ... [A] surge in evictions and homelessness will indubitably be a key dimension of the present crisis... What is to come then will be yet another round in the systematic unhousing of people, a process that has been underway in Los Angeles for a while now. . . it is precisely such crisis that requires us to consider housing justice. Inspired by Black Studies scholar, Clyde Woods, we refuse to become "academic coroners," using our tools only for "autopsies" or "social triage."

—From the forward of UD Day: Impending Evictions and Homelessness in Los Angeles, UCLA Luskin Institute on Inequality and Democracy, May 28, 2020

I'm wearing a plain blue medical mask when I meet with Gary Blasi in the shade of a cabana perched on the steep slope behind his home in Griffith Park. His mask, made by a friend, exhibits the story of his family: his parents lived in Oklahoma during the dust bowl but were "too poor to become Okies." One needed a car to leave for California and they didn't own a vehicle. In one

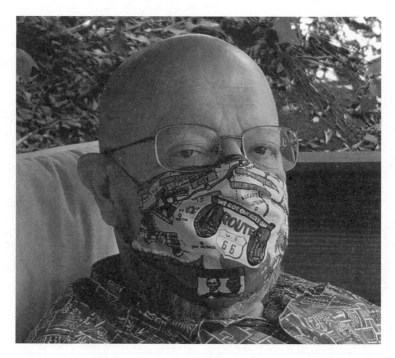

Gary Blasi.

year during the Great Depression, his family earned a total cash income of $7. "They only survived because [my grandfather] was a circuit preacher who rode around on horseback to these little farms and they'd give him a chicken for a sermon." His father later got a blue-collar job in the town of Liberal, Kansas, where Gary grew up. On his face covering are images of Oklahoma, Kansas, and Los Angeles. "So my entire life is on this mask."

Gary is professor emeritus at UCLA's law school, and a luminary of public interest law. His backstory may explain his passion for caring about the working class and having spent one month crunching data to create the UD Day report, which predicts refugee camps on a scale never before seen in America. That report, released two weeks earlier, is filled with terrifying figures that would be sensational were they not based on hard data, about coming evictions of laid-off workers who won't be able to pay rent, after benefits (if they have them) run out, and "UD Day" arrives, which means the filing of "unlawful detainer" complaints to force people out of their homes after the cessation of the Judicial Council of California's April ruling on a moratorium. The freeze could be lifted at any time and he expects it will end before the year is out. On the high end, the report estimated "120,000 households in Los Angeles County, including 184,000 children, are likely to become homeless at least for some period over the next several months." On the low end, it meant "36,000 additional homeless households with 56,000 children." That's a range of some 100,000 to nearly 400,000 people, some of them headed for the Snake Pits of California. In Los Angeles County, rentals compose 54.2 percent of housing, "the second highest rate of any metropolitan area in the country." New York City is first. But only 5 percent of the homeless are unsheltered in New York, compared with 75 percent in Los Angeles, according to the U.S. Department of Housing and Urban Development. New York guarantees shelter; Los Angeles does not.

California, with its stratospheric housing costs, will be especially hard hit. Between 4.1 and 5.4 million residents are at risk of eviction, according to the white paper by the group of advocates and academics. The next closest states are New York, with 2.8 to 3.3 million; Texas, with 2.6 to 3.8 million; and Florida, with 1.9 to 2.5 million.

Gary says he was very conservative when he crunched the numbers, using a variety of sources, such as the U.S. Bureau of Labor Statistics, U.S. Census data, and the Los Angeles Homeless Services Authority, among others. "For these reasons, the estimates of the scale of the impending waves of eviction and homelessness are likely to be underestimates," he wrote in his report. For example, as of early May, some 599,000 workers in Los Angeles County who lost their jobs lacked unemployment insurance or other means of income; this included undocumented workers, who are ineligible for any measures Congress might pass. "About 449,000 of those unemployed and with no income live in about 365,000 units of rental housing and have long been bearing the second heaviest rent burdens of all the urban areas in the United States," Gary wrote, later adding, "Those facing eviction will be heavily concentrated in communities and neighborhoods with larger percentages of low-income people of color."

There's a lot more data in the report, but you get the idea of the scale. The report questions what, if anything, the local, state, and federal government might do to prevent a biblical level of homelessness. Gary wrote, "Somewhere near the last resort are large government-operated camps populated by people living in tents, essentially refugee camps for people who have been displaced not by war or natural disaster, but by an economic and political disaster of historic proportions."

UD Day comes when the Judicial Council lifts the ban on evictions. "That single rule is holding back this flood of evictions. So that's the dam. And that dam will break all at once."

Gary told me all of this in the T-House, named by his late wife, Kit, ("it all began with our falling in love with teahouses in Japan and my taking an extension course on classic teahouse design"). We were surrounded by a botanical garden of global flora as one can only find in Southern California: a Canary Island palm, traveler's palm, Japanese maples, a rhododendron, giant timber bamboo, Buddha's belly bamboo, yucca, agave, red juniper, wild iris, New Zealand flax. The quiet setting was in stark contrast to our discussion of what was going to happen, which he likened to the devastation of an 8.0 quake.

"You can put up refugee camps pretty quickly. FEMA has got all this planning for catastrophic housing. I mean, it's what they would do after the big one, right? Well, this is the frickin' big one. In fact, this is so much worse than the big one would be in terms of making people unhoused."

Gary began working with the homeless when their numbers exploded in Los Angeles in 1983, the same time the first big wave hit Sacramento. He represented hundreds of eviction cases for the Legal Aid Foundation of Los Angeles and cofounded LAFLA's Eviction Defense Center. He's watched the situation grow worse year after year, as rents have escalated disproportionately to income. The Federal Home Loan Mortgage Corporation says Los Angeles is the third-most expensive rental market in the nation when compared to the median income of residents. Homelessness increased along with the loss of affordability.

"I guess the whole point of this enterprise was to convince the city and the county that they should get ready for this massive increase, not just the marginal increase that's been going on for years now," he said of the pre-pandemic housing crisis. "This isn't a quantitative shift. This is a qualitative shift. This is from terrible to catastrophic."

One $10 billion plan that came up in the California Senate would have tenants make rent payments with their tax returns for the years between 2024 and 2034. In turn, landlords would

get tax breaks that match the rent they would forgive. "SB-1410 is primarily a landlord relief bill," he said. That bill faced uncertain prospects. "The tenant-activists in L.A. are focused on AB-1436, which would stop all evictions for nonpayment during the emergency and give tenants one year to pay the back rent in order to avoid eviction and, importantly, give tenants thirty rather than five days to respond to an eviction case."

If people don't have jobs, however, they cannot pay back the rent, so these bills could be moot for them. The question is just how many jobs will be lost, and for how long. But some jobs won't be coming back, or people will be making less money for the same work. "There's going to be a cascade effect," he said of those people who can no longer afford the $2,000-to-$3,000-per-month places. They will be looking for cheaper rent, displacing those paying less. "They're going to be replaced by people who have more resources than they do. So it's kind of a squeeze, squeeze out of the bottom."

The problem could be solved at the national level, he said, if the Fed, the president, and Congress wanted to fix it. Trillions are being focused on Wall Street and hedge funds. "It's just a question of will and money. And the money's not an issue because the Fed is just making it up. And they've said they will print as much money as it takes. But that's as much money as keeps the stock market up."

I showed Gary my phone and the picture of the graffito. He cited the Los Angeles Homeless Services Authority's 2020 Greater Los Angeles Homeless Count that was released that morning.

"People from the homeless count that came out today were saying that homelessness among Blacks is four times what it is among whites. That's wrong. It's eleven times. Because they're not using the right metric, what's called an 'odds ratio.' If you're a randomly chosen white person in L.A. County, the odds that you're homeless are one in 457. If you are a Black person, the odds are one in 44. You don't need a Ph.D. to understand why, because

'fucked at birth' is just an empirical description of the life of being Black in America for an overwhelming number of people—from actually before birth in terms of prenatal stuff—and all the way through. A lot of the stuff that happens to people is random, but it's not random. It's rigged at every level against some people and favoring other people."

Postscript: The Judicial Council of California ended the rent moratorium effective September 1. Gary told me by phone that in Los Angeles, "on the track we are on now, it will be the biggest mass displacement of people in one area of the United States in history." He immediately went to work, partnering with legal aid lawyers, tenant organizers, software engineers, and two cofounders of the Debt Collective, a group of financial activists that formed from the ashes of Occupy Wall Street, which has agitated to cancel student debt by flooding the U.S. Department of Education with claims against for-profit colleges and holding debt strikes, among other actions. Gary and the team were creating a website that would allow tenants to electronically file answers to eviction cases within the five days the law allows them. They were also marshaling volunteers to help guide tenants through the process and assembling pro bono attorneys to represent them. "The other thing we're going to be doing is demanding a jury trial. Tenants nearly always lose without a jury. It will take the court more time to process jury trials, so tenants will have more time to prepare their cases." Jury trials in Los Angeles were suspended because of Covid-19 until at least January 2021. Shortly after I talked with Gary, the bills in the state legislature fizzled except for extending the moratorium until early 2021; the Trump administration and the Centers for Disease Control later enacted an eviction moratorium until January 1, 2021, for people earning less than $99,000 annually. These were not solutions and would only delay the crisis.

THE SHOWER OF HOPE

The parking lot was hidden behind a rolling black gate and a tall redbrick wall topped with coils of razor wire glistening in the light of floodlamps. Nearby skyscrapers in the financial district loomed like a dystopian backdrop for a film conjured by the combined genius of Philip K. Dick, William Golding, Frank Herbert, and Margaret Atwood. The Wilshire Grand Tower, at 1,100 feet the tallest building on the West Coast, was topped with a sail-like crest bathed in turquoise LED light whose design critics have favorably compared with those of buildings in Asian cities. The $1.2 billion tower, completed in 2017, was one reality in the movie of 2020 Los Angeles. Another reality was this parking lot, run by a program called Destination Hope, hidden on a side street, where women who lived in vehicles had pulled in for the night.

Aida's compact SUV was stuffed with belongings, to the roof. She told me she had a job, driving for DoorDash, and her complex story followed—everyone who's homeless has a complex story. It culminated in her talking about a list for subsidized housing, which she had been on for some years, and how for some reason, she fell off being at the top of. "And now I'm at the bottom of the list again. I'm like, how did I get there?"

She went off to bed down on the rear seat. Destination Hope is a safe parking program, this lot just for women, and it's operated by the nonprofit the Shower of Hope that, like Loaves & Fishes, has become one piece of a thinly funded NGO poverty-industrial complex. The organization was cofounded in 2000 by executive

director Mel Tillekeratne, who was born and raised in Sri Lanka. When he arrived in Los Angeles in 2003, he was shocked to see the homeless in Skid Row. There wasn't that kind of poverty in his native country, despite it not being wealthy. He was compelled to start a street program to feed the homeless five nights a week. In 2016 it evolved into the Shower of Hope, when the organization started providing a single mobile shower unit, which has now expanded to serving twenty locations that provide two thousand showers each month.

I met Mel in the center of the dark parking lot. He was on his cell phone. When he hung up, he told me that there were far fewer homeless people who slept in their cars using the safe parking lots since the pandemic struck, because the county health department issued an edict just like Sacramento's, mandating that the homeless not be moved, and people could now sleep in their cars close to their jobs without fearing being busted by the police. So they weren't coming to safe parking lots. Employment for many people dwelling in their cars was not the issue. Many had jobs. The problem was earning enough money to afford a place to rent. The crisis won't be over when there is a vaccine and/or Americans develop so-called herd immunity. In some ways it will just be beginning. Mel's expecting an influx of new timers at his showers and parking sites.

"From Professor Gary Blasi's report, what we all know is that there's going to be a huge influx of homelessness," Mel said. He'd jumped on reading the UCLA study as soon as it was published. "The county of L.A.—and not just the county, the whole state and this country—has to look at: how do we work toward maximizing rapid rehousing?"

As we talked, there was a burst that sounded like gunfire. Close. Were those gunshots or fireworks? Mel didn't flinch. "Because there's going to be a lot of people in the workforce who've been working for years who are going to be suddenly homeless because a lot of loss of work. What can we do? One, push them into

housing, but two, if we are really looking at solving homelessness, we have to look at how do we provide employment back for those people? That's going to be the big question post-Covid." He was talking not just about the immediate crisis but the one that would hit six months to a year from now. Mel had a domino theory about permanent job loss.

"Most companies are shifting toward people working from home," he said, which means empty office buildings. Many firms will realize they can save money by not leasing massive amounts of space. "Now if you've got one hundred people working from home, you don't need a janitorial staff of five people cleaning buildings. You don't need a staff of three, four people manning a cafeteria. You don't need two people for security. What that's going to do is that's going to eliminate a ton of jobs." Forever. We talked about the loss of other jobs, such as those in all the little restaurants and espresso joints around these office buildings that will go out of business.

A further worry: Wall Street investors swooping in and buying up foreclosed homes. "How do we make sure these big corporations aren't going to come in, buy all of them, and rent them out?"

There were plenty of policy questions that local, state, and federal officials had been ignoring for years. "How are we going to look at housing? Because we already were in this huge deficit of housing, this housing bubble where housing prices are so inflated. So how do we look past Covid? What are we going to do when there's an influx of distressed properties? Is there a way to save these people from losing their homes?"

But isn't the Shower of Hope helping?

"The truth is, when you look at programs like mobile showers and safe parking, we're not solutions to homelessness. What we do, especially in the time of Covid, we provide a resource that's critical to staying healthy. But in reality safe parking and showers are not permanent solutions to homelessness. What we are is

basically a management system helping reduce trauma for the people who are homeless."

I showed Mel my pictures from the desert.

"The hardest part about housing homeless people? It's because they've given up. Yeah. It's this weird thing. We call it the Shower of Hope. Okay. The only reason we call it the Shower of Hope is because when people take a shower, they're super happy. When a person takes a shower, they come out, there's this weird thing with our psyches. You know, if you don't shave for a while and you shave, you take a shower, you remember how it was before. That's great for people who had it good before. But when you're talking about people who are fucked at birth, what are they hoping for? Now the hope lies in all these people who are awakening to the systemic racism. And they're willing to fight to tear it apart. They're willing to take down buildings to fix it. So I see what's going on in this country. Maybe, maybe now. I was coming up Sunset and there was a bunch of Black Lives Matter people. Mixed race. The tenor was really interesting. I was fascinated by it. It's different now. I've protested a lot. I saw people who I had never seen involved in those protests."

He admitting to reverse-profiling white people based on how they dressed. On Sunset, he said he saw a mix. "They looked like they were from the poorest white demographics to some people from the richest white demographics." To see them with African Americans and other people of color heartened him. "They're so pissed off for an injustice happening to George Floyd that they say, 'Fuck it. The system has to change.'"

In the summer of 2018, I crashed for one week on the couch in the living room of a director I know. He lived a block off Sunset, near the Chateau Marmont and close to where the Garden of Allah had once stood, the hotel where James Agee, Aldous Huxley, and other luminaries stayed when they wrote scripts. The director

and I worked through long nights trying to develop a screenplay adaption of *Journey to Nowhere*. It was the half-dozenth time over the years that someone or some studio had tried to make a film from that book, including eight years in development at HBO— and the effort with the director was destined to be as ill-fated as the others. One night when we took a dinner break, we drove to a restaurant. On the way back, on West Hollywood Boulevard, we came directly behind a cream-and-yellow 1966 Cadillac Coupe de Ville following a flatbed truck with a film crew and movie camera mounted on a boom. In the Caddy sat Brad Pitt and Leonardo DiCaprio, shooting a scene for Quentin Tarantino's *Once Upon a Time in Hollywood*. I flashed back on a moment thirty-two years earlier, when I rode in a car of almost the same year as the one driven by Brad Pitt, a 1967 Ford Galaxie 500, on this very street in what was then run-down West Hollywood.

That fall of 1986, I'd driven south from Sacramento for the newspaper and spent a week looking for someone who was living out of their car, for a project on hunger in California. A few days into the quest, at a soup kitchen, I spotted Wayne and I knew right away he didn't belong. He grabbed some food and we talked. An hour later I was sitting in the passenger seat of his 1967 Ford, cruising west down Hollywood Boulevard. A first-sized roll of bread sat on the dash. At a red light, as he braked, the bread rocked forward and struck the windshield. He looked out beyond the roll at blinking neon lights flashing on faces walking the Hollywood night. Later, when he bedded down, he would eat the bread. In the rear seat were some of his possessions: two suits encased in clear plastic, shiny black wing-tipped shoes, and a painting that had hung in his Houston home.

Wayne was lonely. He was happy to show me the streets where he slept. Each night, a different street, rotating his regular spots all over the city so as to avoid the cops.

I still have his story stored in a box. It's yellowed and difficult to fathom that thirty-four years have passed since I wrote these

words: *His story is typical of the new homeless. He always worked. In Texas his job was as a "hot shot," delivering critically needed oil parts. He often worked two days on end without sleep. Depression hit the oil industry. He lost his job and apartment and came here, thinking he had enough cash for rent while he looked for work.*

"See in Houston, I could get an apartment for $250," he told me. "I mean a good place. I went into one place here worse than a rat hole. And they wanted $850, plus first and last."

His mistake was not leaving sooner, when he had more money. He's done everything right, it seems. Dozens of want ads clipped from the newspaper rest atop his dash. He makes daily rounds. When he first arrived in Los Angeles, he lived in weekly-rate hotels until his money dwindled. By fall, he began sleeping in the car. Now he is down to his last $7.

"Every week, you say, 'I'm not going to slide down one more inch.' What happens? Next week, you're down another inch."

His morning usually begins in a Santa Monica soup kitchen, eating his main meal—a bowl of grease-packed soup. He refused to eat in soup kitchens those first few months.

"I wish I would have went for this food sooner. It's hard to admit that you are living like this, especially when you were in the middle class. . .One thing I want more than a place to live is to be able to get my own food. Holding a sandwich from noon and saving it for breakfast, that ain't no way to live. This bread here, even a hard crusty piece, is good when your stomach gnaws at you at midnight."

Another day, I met up with Wayne and shadowed him as he looked for work. In part I wanted to verify he was really trying. And I wanted to witness how he was treated. I didn't have room in the newspaper to write about all the places he applied that day—he entered over a half dozen establishments; I pretended I was in line at fast-food restaurants, as he talked to managers. He came off smart and sharp, and he looked clean-cut.

Wayne pilots his Detroit-made house on a job hunt. He spies a "help-wanted" sign in the window of a delicatessen.

"Hey, look at that. This is the kind of place I want to work. A small place. Where I can deal with people."

He finds the owner wants a part-time waitress. No luck.

"I applied for eight to ten jobs in fast-food restaurants in the last two weeks. They won't hire a 43-year-old for a minimum-wage job. Here I am, balding and slightly graying. It gets discouraging. Who's gonna hire me?"

More serious than age bias is having no address. He says he lost two cinched jobs when employers checked and found his address was a day-care center for the homeless. There is a bias when you are homeless.

"Believe it or not, this 19-year-old, bombed-out crate with all its scratches and torn interior is a blessing," he said after a long silence. "It's got 152,300 miles now. It keeps the rain out, the cold out, the muggers out. I can't lose it. But I might run out of gas down the road."

Without the car, his hope for a job will be less than nil. He contemplates having to siphon gas. He cringes. But it might be the only option.

"It's no hayride. I'm just trying to survive."

Wayne took me to a spot in Venice, near the beach, in an alley. He was now dead-broke, not a dime in his pocket.

"It's dark. It's quiet. A perfect place. I don't want people seeing me and calling police. I keep a low profile. I keep shaved and clean. I don't consider myself a bum. I'm used to making money. That's how it was. That was then. This is the reality of now."

I drove away from Los Angeles to cover other aspects of hunger, in the Central Valley. Two weeks later I came back to the city. One night I cruised the half dozen spots that Wayne showed me were his favorite. I found his Ford Galaxie 500 and knocked on the window. He told me that he had sold his blood for the first time in his life the previous week. When he opened the trunk to get something, I saw a rubber hose. There was gas in his tank.

He wouldn't say how he got it.

I am telling you Wayne's story from long ago for three reasons. First, I have too much PTSD from immersing in the lives of hundreds of Waynes over the years, and I didn't have it in me to get the phone number of Rudy and Christina and spend the days documenting how they were living out of their car and going through recycling bins. Second, the stories don't change. Just the eras. How Wayne was trying to survive will differ not one bit from those made homeless by the pandemic, who end up living in their cars. Third, another constant: the lack of anyone in power giving a shit to do anything to really change things for the Waynes and Rudys and Christinas of the 1980s or the 2020s. Their stories are the same song playing on the jukebox in the honky-tonk.

I continued into the Los Angeles night after leaving Mel Tillekeratne and the glow of the financial district's skyscrapers. I headed to Santa Monica and then went north on the Pacific Coast Highway. It was after eleven. I knew that many people sleep along the PCH. Sure enough, as I wound my way toward Malibu, cars, vans, and motor homes lined the western shoulder, perched at the edge of the continent engulfed in mist blowing off the Pacific. There were many dozens, but it was impossible to properly count. I stopped and observed one motor home with a few cars behind it, vehicles with the windows blocked by sunshades and clothing, the certain sign of someone living inside. People milled outside one of the vehicles. I didn't cross the road to talk with them. I drove off.

III

NEVADA–COLORADO

FEEDING AMERICA

The nation's largest food bank, began in a rented warehouse in 1979. It was then called Second Harvest. That year it gave out 3.9 million pounds of food. When I was at the newspaper and took part in the big hunger project that was published in early 1987, it was 100 million pounds. In 1990, 476 million pounds. By 2000 it handled one billion pounds. That was the same year I wrote "This American Is Hungry" for *George* Magazine, thirteen full pages on children facing hunger. One in five kids in America lived in a food insecure household.

The help of Second Harvest was vital in my reporting. Local food banks and the national office eagerly assisted in putting a human face on the growing problem of food insecurity. At the California newspaper, I was one of two lead members of a team of thirty reporters, photographers, editors, and others; we spent six months on that multiday series on hunger that included the story on Wayne and his Ford Galaxie 500. California legislators later cited our work when the state raised the minimum wage by nearly a dollar an hour. The assistance I was given from Second Harvest on all these projects was a classic intersection between a nonprofit with a simultaneous mission to both help alleviate suffering and raise awareness and public interest journalism. It's a symbiosis.

Second Harvest is now called Feeding America.

"Due to the effects of the coronavirus pandemic, more than 54 million people may experience food insecurity in 2020, including a

potential 18 million children," the Feeding America website said. It now comprised two hundred food banks and sixty thousand pantries. Before the crisis, one in seven Americans was served by the organization. Then the pandemic struck. In Las Vegas, at Three Square Food Bank, part of the Feeding America network, there were news images in April of a line of cars four miles long at a food distribution site.

I wrote an email to Three Square. I received a reply from K.C. Kappen, a senior PR Specialist at The Firm Public Relations & Marketing, described by the Las Vegas Chamber of Commerce as a "full service PR and marketing company that specializes in healthcare, luxury, travel & tourism, construction & development and social media." Kappen suggested we talk by phone.

You want to tell the story and this is clearly something you've been working on for years. Just to give you background, in the last couple of weeks, you know, given that Vegas was such a targeted place for media to report on for the state of the economy and food banks being an indicator of that—we just got done with a huge round of media requests.

Kappen said the food bank accommodated CNN and the BBC and that the lesson it learned was that camera crews deterred a lot of clients because they were embarrassed. *And we just declined a lot of media access for that reason, if that makes sense.*

It didn't make sense. *I'm not going to have a camera crew. It's just me.*

I just want to set expectations for you that we've declined the last four similar requests so far. I will work with them to run this up the chain and figure out if we can give you access and just see how they want to navigate that. I know you want to get on the ground and talk to people; I know you want to capture the scene from your own camera.

I won't have a camera.

No camera, just interviews?

Yeah.

Well, we've been telling media, we'll give you the interview with Larry [Scott, COO of Three Square.] so you can understand his insight.

But we also have photos that we can share with you that we've taken that were, you know, taken at a time when it wasn't so sensitive—

I'm not interested in photos.

An email arrived in less than a half hour. Kappen informed me that "the organization is still not granting access to media to meal distribution sites at this time."

I am again offered photos from an earlier period. I decline.

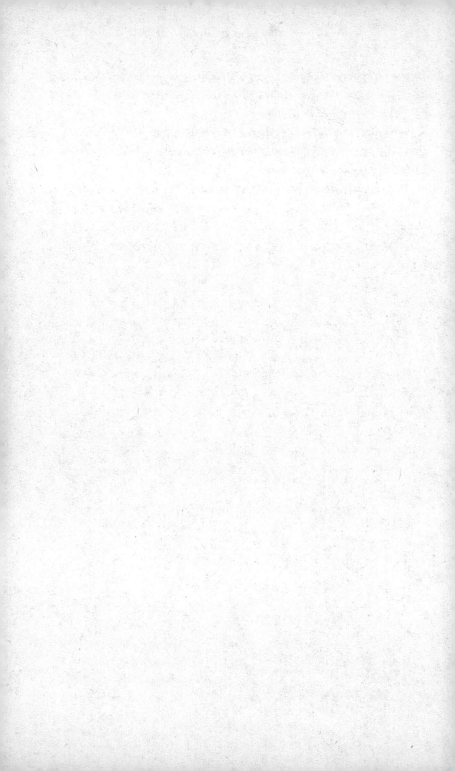

PARANOIA IN FLAGSTAFF

*Socializing has been made easier with technology.
A text and an email do not have the same effect
of person-to-person interactions. In these times
we have FaceTime, Zoom, Skype, and many other
platforms that are the basic human attunement...to
facial expressions and body language that can still
translate. I encourage you to use these platforms,
because while we need physical distance of six feet
away, we still need social connections. Please also
remember that many of our elders in Peach Springs
still have home phones, which allows the social
connections through a tone of the voice. I encourage
you to remember to check up on them. Be safe. Be
well. Be disciplined. But be connected. This message
has been brought to you by the Hualapai Tribal
Education and Wellness Department...*

—Public service announcement on KWLP 100.9
FM, the Hualapai Nation's local radio station in
Peach Springs, Arizona, on historic U.S. Route 66.

*Fifteen items all for under $1...burritos, drinks,
and desserts starting at 69 cents is basically the
world's greatest value. Try our newest dollar deals
like the ChickenCrunch Burrito made with fresh*

grilled chicken and the new 3 Layer Queso Nachos.
The new Del Taco Dollar Deals Menu. The most
options, the freshest choices. The lowest prices!

—Del Taco advertisement, KMGN 93.9 FM,
Flagstaff, Arizona

This is you getting snacks from the pantry.
[silence] This is you getting snacks from the DQ
2 for $4 Super Snack menu. WOOWWWOWOW!
And mixing and matching any two snacks like
the new lemonade twisty Misty with a chili
dog. UH-HHUHH! A cheeseburger with fries....
WHHAATTT! The DQ $4 Super Snack menu.
Two snacks. Four bucks... DQ. Happy tastes good.

—DQ advertisement, KMGN 93.9 FM, Flagstaff,
Arizona

I avoided interstates as I drove east across the upper Sonoran
Desert, into Arizona and the Colorado Plateau, ignoring Las
Vegas. In Kingman, Arizona, I went to a rescue mission on the
crazy chance I'd find a journalist who'd written me an email a few
years back with the subject line "JOURNALIST, WITH INQUIRY
ABOUT HOMELESSNESS." The man thanked me for writing
Journey to Nowhere, because after losing a newspaper job he was
now like one of the people in that book. He rode his bike west
and ended up working the desk at the Kingman mission. "I am a
homeless transient without any money. Three college degrees to
boot. . . So here I sit at the public library computer typing out my
stories and thinking about what to do." I wrote him back and we
had a few email exchanges. In his final correspondence, he wrote,
"Dale, thank you. Thank you more than you know. Well, I bet you
know. And I plan to stay the 'heck' out of Vegas, though I would

love to visit and be guided through the hobo jungle / corridor (Apartheid in Sin City). I will send you a very brief op/ed I wrote to *City Life*, a Las Vegas left bank weekly. You'll like it, I think. I fully understand your schedule. I do want to stay in contact as I think you are a god send. Adios my new friend. —Dave." Then he vanished. I never was sent that piece, never heard from him again. I later tried to locate him, to no avail.

At the Cornerstone Mission in Kingman, the home guard mission stiff at the desk blew me off. As I drove off, I passed a couple and immediately turned on my tape recorder as I glided slowly by:

They're probably in their late fifties early sixties.
He's wearing mirrorized shades.
Sunburned face. Almost sun-scabbed.
White hair.
Floppy hat.
And they have carts with cans in them.
Scrambling to survive in this place.
How many cans do you find in Kingman, Arizona?

I remained on old Route 66, scrolling up and down the radio dial, listening to stations cutting in and out with static. I came to Flagstaff, the road flanked by vintage motels with neon signs, most of them run-down, with late-model cars in front of the units. I stayed in one of these hotels when I was almost three years old, when my mother and six others of us packed into an old round-fendered Chevy and drove to California in 1959. I refused to go in because of a terrible odor. I imagined how the motels now smelled and then I spotted a WENDY ROGERS FOR SENATE campaign sign, and in red, blazing across the top:

PRO TRUMP

As I neared city hall downtown, on my left, there were two dozen or so protesters with BLACK LIVES MATTER signs that they waved. They chanted. Some passing cars beeped horns. I pulled behind city hall and approached holding my recorder and a notebook. The crowd was mixed; Black, Latinx, one Native American, and a few white people. A short young white man with an exuberant beard of the kind one has at the age of twenty or so rushed up. He screamed every word he uttered.

How did you hear about this? You can't be here! We don't know who you are!

I tried to explain who I was.

Have you been contacted by anybody who has called this march?

No.

Then you can't be here!

It's a public street, dude.

I started talking to the Native American man, who began telling why he's here.

A white woman with a plump face, red with rage, screamed, *Fuck you! You can't be here—*

I tried to explain who I was and the white woman yelled to the crowd, *He's not media!* Then she glared at me. *Fuck you! Just go!*

A tall white man said, *Hey, calm down, calm down. It's okay. He's just doing his job.*

I tried to do my job, started talking with a young Latina. The red-faced white woman came up from behind and lied, in a full-throated scream, pointing at me: *He called me a bitch and told me to go to hell!*

I had not called her anything.

Yes, you did! He called me a bitch and told me to go to hell!

"Ma'am, I never—

He's just like trying to stir up shit! Like now you're gonna cuss me and call me a bitch again, so you can fucking go, bro!

Now much of the crowd believed her and chanted *Go! Go! Go!* As I left, I noticed a few people of color were not chanting; one Latina woman looked at me with sympathetic eyes.

I stopped for a coffee at a Starbucks on the eastern edge of old Route 66. In line behind me was a mother and daughter, both with blond hair. The mother had a string of white pearls around her neck and she wore a black dress imprinted with blazing yellow-orange sunflowers. The daughter wore black-and-white running shorts and a crisp, brand-new oversized white T-shirt, emblazoned on the front beneath five red stars:

TRUMP
PENCE
Keep America Great!
2020

If I was working for a newspaper, I'd talk with them to balance the story, but I wasn't working for a newspaper. I'd experienced enough exclamation marks for the day.

THE COLORADO PLATEAU

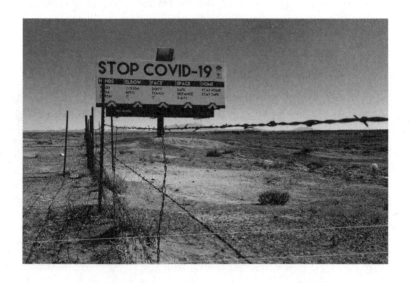

I crossed the red rock high desert of the Navajo Nation on U.S. Route 160. To my left I caught glimpses of Navajo Mountain, 10,388 feet, an isolated, dome-shaped formation rising above the Colorado Plateau. The Navajo people, Diné, call this sacred mountain Naatsis', which means "Head of the Earth." It was on the western flanks of that mountain that I first met Native Americans.

The year was 1976 and I was nineteen. I'd spent a month and a half on a vision quest, walking with a backpack from near the confluence of the Green and Colorado Rivers in Utah, west toward the Grand Canyon. I went east-west against the grain of the land; hundreds of north-south canyons were like lacerations cut through the slickrock. I used a rope to rappel and climb as much as I walked. It was slow and difficult going. By May I was

an emaciated 115 pounds, starving, and I abandoned the plan to conclude my walk at the Grand Canyon. I hitched a ride on a boat across Lake Powell, the reservoir that flooded Glen Canyon and the Colorado River, and hiked south on the rugged Rainbow Trail, made famous by the writer Zane Grey after he made a pack trip on the route in 1913, which later inspired a novel of the same name. I came to a series of seemingly endless switchbacks that ascended a near vertical escarpment. I was midway when I heard the clattering of rocks far below. A Navajo boy, perhaps twelve or thirteen, walked ahead of a very old man with a heavily lined face, and they were leading a horse up the trail.

I was so weak they caught up to me long before the top of the switchbacks. There was nowhere to go, caught between the rock wall and the sheer drop below. They spoke to each other in the Navajo language. Almost nothing about them said that it was 1976 and not 1876. I'd passed hogans made from juniper poles in the canyons where people appeared to seasonally live. The boy came up to me and explained that the horse had spent the winter in the canyons and was wild, that if the horse saw me, it would spook. He asked me to hide. I wedged my pack between boulders, pulled myself up over a boulder, and then forced my body to fit into a crevasse. I didn't feel very hidden. But it was the best I could do. I held my breath as the man and boy led the horse past. When they were two switchbacks above, the old man came to the edge and looked down, smiling. He spoke in Navajo and waved, and it seemed he was thanking me. But I felt like shit.

Perhaps that incident is why I have always feel out of place on any Native-American lands and why I chose to never seek out to report on Native American issues: I'm just as out of place as a journalist as I was at age nineteen on that mountain. I can count on three fingers the times I've written about them, and two happened when I was a general assignment reporter at the

newspaper, and the desk assigned me to do stories on Deganawidah-Quetzalcoatl University, located west of the city of Davis. D-QU provided an alternative learning experience for Native and Chicano students based on preserving traditional beliefs and values; it was on a 643-acre former U.S. Army facility. There was a rumor that the government would take over the university, and I was there to cover it one morning; the takeover didn't happen. The threat "dissipated like cedar smoke from a ceremonial fire that filled the room where supporters gathered for a 72-hour prayer vigil," I wrote in an October 26, 1982, story. The deadline set by the government to vacate ended up in a drawn-out court battle. D-QU had the enmity of conservatives, who focused on it because its chancellor was Dennis Banks, a cofounder of the American Indian Movement. He took part in the occupation of Alcatraz Island between 1969 and 1971. AIM leaders, including Banks, made an armed takeover of Wounded Knee in South Dakota. During the seventy-one -day siege, a U.S. Marshal was shot and two Native Americans killed. Governor Jerry Brown pardoned Banks and refused to extradite him to South Dakota to be tried for his part in Wounded Knee.

Banks was a man of few words, at least he was the day I covered the presser. I recall him sitting at a table with a faraway gaze. He looked tired, worn out. I only had one quote from him: "If they pull a surprise move, that would not surprise me," Banks said. "But legally, they don't have any authority to move on us now." Banks had to flee California when a Republican governor followed Brown. He eventually turned himself in and served eighteen months in prison. Banks died at the age of eighty, of natural causes, in 2017. AIM petered out over the years. The economic plight of Native Americans didn't change.

The Navajo Nation, with over twenty-seven thousand square miles, is the largest reservation in the country. It has 180,000 residents and the median household income is $20,000; 43 percent of the people live below the federal poverty rate. It was primed

to be hit hard by the coronavirus, which appears to have struck after someone was allegedly infected at a Christian revival on the reservation. That was in early March, and the pandemic rapidly expanded: when I drove through in June, when compared with all fifty states, it had the highest per capita rate of infection. Some 40 percent of the homes don't have running water, compounding the danger.

I'd reached out to an organization that was taking water to isolated parts of the nation, as well as a few activists. I didn't hear from any of them. I confess to not circling back with more emails and phone calls; part of me felt like that out-of-place nineteen-year-old. I figured I'd leave it to chance to talk with anyone out doing something public, speaking with a mask on and from a great distance. But all the stalls where residents sold crafts at the side of the road, were empty. Tuba City, which normally has a lot of people out on the street, was devoid of pedestrians. There were weekend curfews, and people were urged to stay home and wear masks if they had to go out. I certainly wasn't about to knock on doors. Signs were everywhere, warning people to remain home and to be careful.

I spent the night in Moab, Utah. On the road to Denver, I stopped in Grand Junction, Colorado, and headed to where the hobo jungle had been. In 1982, Michael and I came into town in a boxcar with Ken Gibson, an unemployed construction worker. It was his first time riding trains. We waited overnight and then jumped on a Denver & Rio Grande Western grain car; we followed Ken to Denver and documented him looking for work. Then he caught a train to Texas, where he heard there might be jobs. Ken had the most plaintive face of any of the men I'd seen crash into hard times—he looks like a scared child in a picture Michael took of him when the train went through the Moffat Tunnel over the Rockies.

The D&RGW has long since been merged out of business. The line is now the Union Pacific. There was no sign of hobos in the

sandy expanse of scrub brush on the north side of the yard where we'd jungled up in 1982. No fire pits, no litter. I guessed that not too many trains stopped here any longer, or perhaps that the yard was hot. Or maybe there were fewer hobos these days. Some years ago I tried to find Ken Gibson. But so many of the people we documented had common names. It was as if I were chasing ghosts. I could never track him down. I wondered if he made it. A lot of them didn't.

IV

DENVER

STRUGGLE OF LOVE

Joel Hodge was waiting in a parking lot behind a school. He was missing his right eye, but the left was bright and welcoming as we Covid elbow-bumped. He most certainly did not have a public relations firm working for him: when we talked by phone, he said to just show up any time that morning at the mobile distribution site, located in a neighborhood that is 90 percent Latinx and Black, with a large number of them immigrants living in poverty. Joel is cofounder of an organization called Struggle of Love, which operates a food pantry in the Montbello area of northeast Denver. It copied the drive-by model seen in Las Vegas and many other food banks, to lessen the risk of viral transmission.

Struggle of Love's primary mission is helping at-risk youths with programs that include tutoring and sports. A food pantry was a small piece of the organization's mission. Then came the pandemic. Before mid-March 2020, some 150 to 250 people, mostly senior citizens, were given food each week. "We've jumped up to 2,500 people a week," Joel said. They would give away more food, but they usually run out.

It was well before the eleven o'clock distribution time and he gave me a tour. Pallets of fresh produce boxes, with raspberries and lettuce, were stacked eight feet high beneath shade canopies in the parking lot. Coolers held frozen ground beef and pork. Inside the school, tables in a hallway were laden with loaves of bread and rolls in clear plastic bags. The school was closed

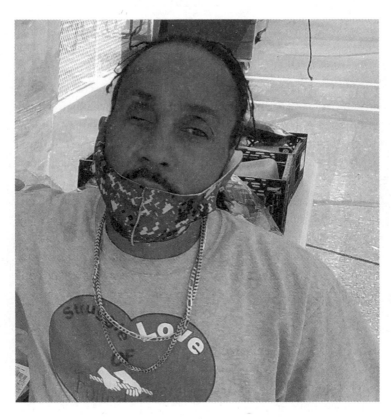

Joel Hodge.

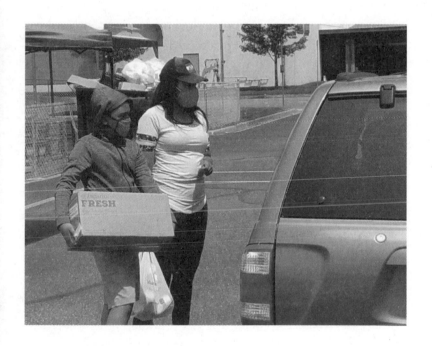

because of the virus and the cafeteria's tables were loaded with canned and boxed goods. During the tour, Joel told me his back-story in bits and pieces. He was raised in public housing at Sixty-Third Street and South Wabash Avenue on Chicago's South Side. "I was molested from eight to ten years old by this pimp that my mom was dating." The city's largest street gang, the Gangster Disciples, was feuding with rival Black Disciples. One month before his eighteenth birthday, he got caught up in this. "I got hit with a baseball bat first. They knocked me out and shot me three times." Two bullets in his back, one in the head—that's how he lost the eye. He eventually went to prison in Colorado. When he got out in 2001, he was homeless. Not long after that he and his wife LaKeshia founded Struggle of Love.

A steady flow of vehicles began arriving after eleven. One, with a white driver, was a Yukon XL, which has a base price of $53,400. I would guess about a quarter to a third of the vehicles I saw in the next few hours were driven by whites, most of whom were clearly uncomfortable getting charity food, which dispelled any doubts one might have that they were scammers simply coming for free food. Their faces were dour. Most were not inclined to talk. One white woman mumbled, "I got laid off," then she looked down. Another told me, "There's six people in my house and I'm the only one working." About half of the vehicles had children inside.

Some white and Latinx people are troubled by getting food from black people, Joel said. He sees it in their faces when they drive up. Black people giving them something doesn't compute. It should be the other way around. Joel imagined the thought process behind how they looked at him: *I gotta go accept something—from as much hatred that I said about these people—from them.* Joel gives away the food with the help of volunteers and children who are in the other Struggle of Love programs—most are African American. One white woman asked, "Who's doing this?" Joel recalled. "I said, 'I founded this organization.' She , 'Oh no you didn't.' I just said, 'Thank you, bye.' I don't even get upset because it's just

retarded. But it's the image, you know what I'm saying?" he said of how some whites view Blacks. "So we just got to change the way people think. We're not all criminals. Another woman, Latina, saw the car ahead of her get two boxes. When she was given one box, she complained.

"I said 'cause you're one family,'" Joel recalled telling her. "The other people had two families. So she said, 'That's not right. I want to talk to your boss.' I said, 'Listen lady, the only boss to talk to above me is God.'"

Volunteer Demetrious Jenkins greeted a car with a Latina driver. He handed her a box of fresh produce. He spoke in Spanish, then switched to Spanglish. "You want *tomate* too?" he asked the woman. He held up a dozen eggs. "*Juevos*, baby!"

"We meet them where they're at," Demetrious, who is Black, said after the woman drove off, about speaking Spanish to the large Latinx population.

In the early days when the first rush of newbies came, Demetrious said, "We had a lot of folks who were coming who had vegan appetites. They were being really picky. Like, *'We don't do this. We don't do that.'*" He told them, "'This is not a vegan food pantry. You don't get to pick and choose and say you're looking only for fish or do we have tofu and things of that sort. There's going to be pork in here.' We saw a big wave of that early, multitudes of people asking that. This must be the first time they've ever had to do it. If we try to cater to every vehicle that came through the line, it would be ridiculous."

These first-timers were mostly younger than forty-five.

"They don't know how to navigate through the system," Demetrious said. "So you feel like you're entitled because you never had to do this, or just because you truly don't know the process, you think that you can come in here and request items. For folks who've had to go through this process before, they know. They come in, whatever you put in their vehicle, they smile. They're very grateful, humble."

Demetrious doesn't inquire about people's professions—he only knows that many of the newbies are laid off or jobless. "I see a lot of Jaguars, Mercedes-Benzes, BMWs, Infinities. Some of your larger-model trucks, F-150s, Chevy Suburbans. So I'm assuming they had a pretty good position or title, prior to becoming non-essential."

Both Joel and Demetrious talked about who has the "good" jobs now—the people doing certain service and delivery gigs who are still working. Joel lamented their pay. "For all of these essential workers that's out here serving you food or whatever it is, pay them. So right now you got the minimum wage, $15 an hour. That's $600 a week full time. After taxes, what do you bring home?" he asked. Something less than $400. He said rent for a decent place was $1,800, or in the 'hood maybe $1,200. Do the math: most or all of the take-home goes to a landlord. "Everybody's had enough. Everybody's just tired—tired of busting their ass for pennies."

Out came my phone and the two pictures. Joel studied the second one for a while.

"Well, the message speaks for itself, don't it? You're fucked at birth. You're fucked since birth. Everybody. Everybody born into America is fucked."

He was referring to those without money. Joel invoked economic inequality, focusing on Jeff Bezos.

"Look at Amazon. You're making billions of dollars. You pay people $12 an hour. Are you sick in the head? Are you that evil? Are you that dirty? Has money made you that evil? Really? What else could you buy? I mean, you own half of America, what else do you want? Covid just proved what everybody knew already."

In America, Joel added, "We're all born to hate something, for some reason. I don't understand. You know, it's kind of confusing to me. Like everybody has these superpowers, you got two superpowers inside of you, right? A positive and a negative superpower. You got two superpowers and those superpowers are really powerful. If you constantly think of negative, those superpowers are going to run your life, you're going to be negative. Everything you see, everything you look at, is *negative, negative, negative, negative, negative.* But if you affirm your positivity, those superpowers take off and they will prevail, and give you strength that you never even thought you had. So that's what I tell the kids. You have two superpowers."

BLM

Aurora, Colorado: On August 24, 2019, Elijah McClain left a convenience store on Colfax Avenue after purchasing tea for a cousin. The twenty-three-year-old was wearing a face mask, something he often did because he was anemic and easily got cold. Someone called 911 and reported a "sketchy" person. McClain didn't answer responding officers at first because he was playing music and didn't hear them. There is body camera footage—blurry—and in the audio McClain says he is an introvert and wanted the officers to leave him alone. Three cops wrestled the 140 pound McClain to the ground. One cop said McClain reached for an officer's weapon. But that's not seen in the body cam video. A cop put an arm around McClain's neck—a carotid hold—and McClain gasped, "I can't breathe. Please stop." McClain was handcuffed. He vomited several times. He was injected with a powerful sedative, ketamine, by paramedics. He had a heart attack in the ambulance. Three days later he was declared brain dead. The three officers were suspended but then reinstated a few months later after a review board cleared them of wrongdoing.

Terrance Roberts, a civil rights activist, joined some other community leaders fighting for justice in early October. There were only six others present at that meeting. "No one cared, even locally," Terrance said. Yet another Black man dead by the hands of police was going unnoticed.

The Denver area is one of America's most racially divided metropolises. It's ripe with racism, a long history of which in modern

Terrance Roberts.

Terrance Roberts.

times dates to February 5, 1970: that night, after eight Denver families filed a lawsuit against the school board, contending that Denver's public schools provided unequal education because they were segregated and that busing to integrate the schools was needed, someone bombed the DPS bus depot. About one-third of the fleet of school buses were damaged in an ensuing fire. *Keyes v. School District No. 1, Denver* made its way to the U.S. Supreme Court. Justice William Brennan wrote the opinion that affirmed the need for busing. Denver, the opinion said, was a "tri-ethnic" city, and "Negroes and Hispanos in Denver suffer identical discrimination in treatment when compared with the treatment afforded Anglo students." The busing plan went forward. A likeness of Brennan was hanged in effigy by protesters in Denver. What ensued was the quiet violence of abandonment. Whites fled the city. Between 1970 and 1975, enrollment in the district fell 21 percent. In 1974 the Poundstone Amendment was ratified by voters. It reined in Denver's growth—a measure that really meant prohibiting the city from annexing adjacent districts where whites had fled and instituting busing.

Today some city schools are 90 percent non-white. And the cops in Aurora appeared to get away with killing another Black man. By November, the meetings seeking justice for Elijah McClain had grown, attended by "ten, then twenty, then thirty people," Terrance said. They crafted a bill for the Colorado State Legislature, which they called the Elijah McClain Police Accountability Act. They met with leaders of the Black Democratic Legislative Caucus and were told "the time is not right." Terrance was frustrated and angry. He wondered: *If not now, when?* The idea languished. But then came May 25, 2020, when George Floyd was killed by a Minneapolis cop kneeling on his neck. Black Lives Matter exploded across the nation. On May 28, Terrance was in front of thousands of people at the state capitol building. Then about a week later, he was at the microphone in front of the Aurora Municipal Center, speaking to hundreds of protesters; he wore a gray T-shirt, with white lettering on the chest:

Elijah McClain
#JUSTICE4ELIJAH

By the third week of June, Terrance's lonely quest, which had begun eight months earlier with just a half dozen other people, had gone national: a Change.org petition asking that McClain's police killers be held accountable had 2 million signatures. By July 4, the petition registered 4.1 million signatures and the website said it was "the biggest petition ever on Change.org."

After reporting on numerous movements over the decades, one becomes cautious about ascribing the word "leader" to anyone. Many of those who jockey to be recognized as such often are not. Those listed as the heads of groups are sometimes titular, eclipsed by others without official title. When I asked Terrance about his being a BLM leader in Denver, he replied, "I am just really a community organizer for the movement of Black lives mattering, but not part of the organization." His group is the Frontline Party for Revolutionary Action. The story of his becoming a community organizer is a street Lazarus tale on both a personal and public front: he's been literally and figuratively left for dead more than once. In writing Terrance's virtual obituary, when it looked like he would spend the rest of his life in prison, a writer for the local magazine *5280* wrote in a long profile that Terrance was an "outsize presence in his community."

Terrance was born blocks from the Holly, Denver's longtime African American community, to a crack-addicted mother. He became a Blood in the early 1990s, known as "CK Showbiz." The "CK" stood for Crip Killer. Showbiz was shot and nearly paralyzed in 1993. He spent the ensuing decade in and out of jail and prison on drug and weapons charges. When he emerged for the final time, Showbiz no longer existed. He found God, declared he was no longer a Blood, and chose to turn his life around. He

went back to his roots in the Holly and created a youth violence prevention program.

It was not easy going. The situation intensified in 2008, when the Crips burned down the Holly Square Shopping Center, the heart of the community. Terrance made it his mission to rebuild. At first he was heralded and drew the support of the power elite and wealthy in Denver. By 2012 he'd raised enough money to create basketball courts, a soccer field, a playground, and other improvements.

But as time went on he questioned how gentrification would hurt the African American community. He called out police racism; he pointed out that white developers weren't hiring Black workers from the Holly. He had enemies on all sides—including in the government and in the Bloods, his former gang, because he was steering kids away from them. On September 10, 2013, Terrance organized a peace rally, that turned ugly. He was surrounded by angry Bloods. A police report says someone shouted, pointing to Terrance: *There he is, right there! Let's get him!* Terrance had a 9mm and he shot Hasan Jones, twenty-two, who was coming at him. Jones survived but was paralyzed from the waist down. The district attorney offered a plea deal, which would have meant ten to thirty-two years in prison if he admitted guilt. Terrance declined. So the district attorney added "habitual criminal offender" to the charges, which meant that if convicted, he faced 102 years in prison, with no chance of parole. Terrance alleges a wider conspiracy involving police informants but that didn't factor into a jury acquitting him of all charges in 2015, based, in part, on video footage showing he was being attacked and justifiably fearing for his life.

Now I was in the living room of Terrance's ground-floor apartment, in a nondescript working-class complex with dozens of units in several buildings, southeast of downtown, about

a mile from the Aurora city border. The brown leather couch had frayed cushion edges from years of rubbing legs. Near the sliding patio door were thirty-pound barbells. A mama duck and ducklings waddled past what leasing agents would call the "garden apartment" unit. A few days earlier the door was open and the ducks came inside to hang out, Terrance said. The door was closed and the ducks couldn't enter, though they seemed eager to visit. The room was otherwise sparse. There was a plain table and Terrance pointed to it—that's where he and Candice Bailey, an organizer, finalized a revised version of their bill in the wake of George Floyd's murder, the same bill they'd started after the killing of Elijah McClain. It would require that police use body cameras, set up a statewide database of bad cops, ban choke holds like the one used when Elijah McClain died, and end "qualified immunity" for cops, which enables them to not be held liable when someone dies due to their actions.

"We wrote that bill right here on that table," Terrance said, proudly. "Right there! Man, this is the most advanced penalty-written bill so far! In the history of policing in America. I support it even if it's not everything I want." They took the bill to Representative Leslie Herod, the first gay African American ever elected to Colorado's state legislature. This time they weren't shunted away. Senate Bill 20-217, known as the Police Integrity Transparency and Accountability Act, was about to come up for a vote. There was a problem, however—some older, religious African American leaders felt left out of the process. Terrance invited me to observe, off to the side, a Zoom meeting among those religious leaders, African American politicians, and activists. It was a contentious and heated discussion, and one activist left the Zoom meeting in a huff. No one disputed the contents of the bill—egos simply had to be stroked. The conversation raged and things were going off the rails. Terrance remained mute. Finally, thirty-six minutes into the one-hour meeting, Terrance asked to speak. Everyone silenced for the first time and listened.

"Pastor, Man, I hear you when you said you guys feel disrespected. I feel that way myself. You know, my grandmother owns the restaurant on Twenty-Eighth and Fairfax. I grew up there. You know my history. I was gang-banging, very heavily involved with violence and gangs. You brothers used to come and minister to me, helped me get out of that. I've worked with Reverend— when I redeveloped the Holly Square, I would have my meetings in his church over at the Urban League, so you know I understand the perspective that you guys are coming from. Don't think that I don't understand how you feel. As we move forward with this, it was not about leaving you guys out, or any form of dishonor to you guys as our elders. This just came from us organizing around Elijah McClain and some of these other police killings. We just went with the group that was present. When I seen the videotape around what happened to Elijah McClain and when I heard that officer say, 'Dude, cover your camera,' I came up with the idea about drafting some type of legislation around them wearing body cameras,...not being able to take them off or cover them, and if they do, what I presented to Representatives Herod and [James] Coleman, they should catch a felony conviction. I met with Candice, some other organizers, we met in my living room where I'm sitting right now on my couch. Candice had already been working on some stuff like this previously, and we kind of combined our ideas. And then we had a meeting with Miss Herod and Mr. Coleman. And we tried to talk to them about it, and at that time, the time was not right. I just wanted him to run with it even if it wasn't the right time, but, you know, I'm willing to learn, too. I'm willing to listen, just like I listened to you brothers as elders. And they explained to me, Terrance, that this wasn't the time. But now? The time is now. That's why we run with it now. I studied the bill, and my own personal wants in the bill have not been all included. But I also understand that some of what I want is in the bill—them wearing body cameras—it's gonna save the lives of Black men

and women, especially our youth. There could be more teeth in this bill, but like Representative Coleman told me just the other day, they're running more bills in January. And so I'm standing behind it...[E]ven though there was no dishonor to you guys as our elders for not including y'all initially, but you guys weren't there around Elijah McClain. That's just facts. There's things that you guys do as the faith community, helping young Black men. But we do have a disconnect in our community, how we deal with each other. I've always worked with the Ministry Alliance; I started my organizing career with all of the pastors in the churches in Park Hill...It was just a fast-moving thing, man. We're just in the middle of a war—we're fighting a war. I don't want you guys to feel there's any disrespect because that is not the intent. We even had a little attitude about feeling not included. So don't feel left out. Just know that we have to do it fast. And we need you brothers to support this, man. It's good for all of us. And we need to work better together so we can avoid this type of situation in the future. And that's all I gotta say about that."

Terrance talked longer than anyone else. No one attempted to interrupt him in a Zoom meeting that had been filled with interjection. After Terrance finished, the tenor changed. Terrance's words smoothed over a lot of tension. When he clicked "end meeting," he sighed. The pace of events in recent weeks since George Floyd's death was dizzying. He said that "there'd normally be twenty people" at an action. A few weeks earlier, when he spoke to thousands from the steps of the capitol, "it almost made me want to cry. I couldn't believe it." He had a full-time job and the activism was a full-time job. He didn't sleep very much. But this was a moment. "Of course I'm writing police accountability bills in my living room. Of course I'm protesting Denver police, Aurora police, Minneapolis police, NYPD, LAPD. Fuck all of them."

I showed Terrance the pictures on my phone.

"You ask me about being fucked at birth? I mean, I'm an African American male."

The answer seemed obvious, kind of a *duh*, uttered as if there was no need for me to have presented the question. His tone of voice was resigned.

"I grew up in an all-Black community," he continued, and he explained how he had assumed there were a lot of African Americans in the United States. He said "it blew my mind as an adult" to discover, as he went out into the world, how few Blacks there really are—just 13.4 percent of the population, according to the U.S. Census. "There's not a lot of Black people. What is it with this obsession, fighting us and hurting us, and starting these Proud Boys and all these different organizations? Man, we're such a small piece of this pie. What can we possibly do to hurt y'all? Where's this Proud Boy energy and thought pattern coming from? A lot of their ideology centers around immigrants taking their jobs, or Black people. Or they say Black people are lazy. Black people didn't start getting called lazy till we stopped working for free. That's economic. Juneteenth coming up in two days, Juneteenth is about slavery ending. It took two years for slave owners in Texas to free their slaves. Why? Because millions of dollars, pretty much billions of dollars, in free labor is better than paying billions of dollars *for* labor.

"So we got a lot of issues around economic justice that we're fighting. I'm forty-three. I just now came to the realization that America could have been giving African Americans some type of reparations. I just didn't even think it would be possible. It would be trillions of dollars. But with Covid, they're just printing [money]." The money was always there, he said, if there was a will to spend it. Joel Hodge had told me this exact same thing the day before. For Terrance, this concept got him to thinking about money in a domestic and international context. He looked to Africa, where money was backed by the value of natural resources such as diamonds, gold, and other minerals.

"I came to the conclusion that America's money is not backed by corn. Our money is not backed by cotton. Our money is backed

by our *MIL-I-TARY* might," he said, dragging out the word for emphasis. "You understand? That's like our natural resource. That is what our dollar is backed on. Military teeth. We can come to your country, cause problems, and create a war. Without that, what covers this $10,000 that you have in the bank?"

By extension, police departments are part of this mentality of projecting sheer power.

"That's why some people are against this kind of legislation," he said of SB 20-217, "who care nothing about police violence, or they don't care about how many Black men get killed. They're mad about the protests because they feel like their livelihood and everything America stands on is backed by policing. Keeping our knee on Black people's necks, Mexicans, people of Latin descent from various countries, and poor white people. Just because you're white doesn't mean that you just instantly play the game, right? I've seen white people who don't speak the language of the rich. So not only are we fighting racism—that's why Black people don't have the resources, because of racism—but just as bad in many ways as racism? Classism. Because if you're poor, no matter why you're poor, you're still fucking hungry."

On Juneteenth, two days after I left Terrance, Colorado governor Jared Polis signed SB 20-217, which had true bipartisan support—only fifteen of the state's one hundred legislators opposed it. A friend sent a picture of Terrance holding a microphone on the steps of the capitol building right after the bill was signed. His right arm is raised in a Black power salute.

On September 17, 2020, I sent Terrance an image of this book's cover via encrypted Signal text. He replied, "Thank you for including me, I really appreciate it!" He then began jogging around Denver's Washington Park, but was surrounded by eight patrol cars. He was arrested for "inciting a riot," a felony, and several misdemeanors related to four protests that summer. Five others were also charged. Terrance bonded out. He faces years in prison if convicted.

V

MEAT TOWNS

CRETE

In Crete, Nebraska, population 7,082, fifty miles east of the 100th
meridian that unofficially marks the boundary between the arid
American West and the wetter eastern United States, there's the
obligatory WalMart supercenter outside of town. Grain elevators
rise on the horizon, marking the location of downtown, a strip
of century-old redbrick buildings, many with empty storefronts.
If you didn't know this was a meatpacking town, some of the
signs and names of open businesses that cater to immigrants
are a giveaway—it's mostly Latinos who cut up hogs. *ENVIE SU*

DINERO A LA LATINOAMERICA. FACIL, RAPIDO & SEGURO. ANTOJITOS GUATAMALTECOS. Amid them is the New Beginnings Thrift Store, stripped bare, with a FOR SALE in the window. From South Main out, the road is paved all the way to the Smithfield Foods plant. Beyond that, the road turns to gravel. On the right is the sprawling plant where ten thousand hogs meet their demise each day.

Dulce Castañeda's father is one of the workers in that plant. When coronavirus infections tore through the meatpacking plants in towns in Nebraska and Iowa, she worried about her father's health. The Nebraska State Department of Health reports that while Latinos are just 11 percent of the population, they constitute some 60 percent of those with confirmed cases. Workers often stand shoulder to shoulder in the plants, which are kept just above freezing, and work rapidly with sharp tools to disassemble animals. The virus loves the cold. In April, she heard about Children of Smithfield, a small group of children whose parents work for the company, who advocate for "workers' rights and better working conditions for all meat-packing workers." She joined. She'd never been an activist.

Dulce was two years old when her parents moved to Crete in 1996, among the first Latino families to arrive in town. Her parents came to the United States in the late 1980s, from Mexico. She was born in Grand Island. She went away to college and graduated from Northwestern University, majoring in sociology. She came home to Crete and became the city's first community assistance director. After a year and a half, she moved to Mexico. She'd returned to Crete in February, and then the virus hit.

Dulce was confused by how her state's politicians and officials dealt with the crisis. As the virus raged through meatpacking towns in April, Republican governor Pete Ricketts refused to make public how many workers were infected. The state health department also kept specific data secret. Later, in June, Ricketts decreed that he would deny federal coronavirus relief funds if local governments mandated people wear masks while in court

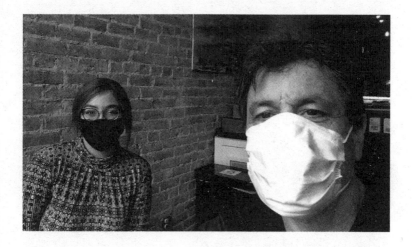

and government buildings. I'd talked with Dulce by phone a few weeks earlier. *At first it was our goal to raise public consciousness and bring awareness to the issue. We've done political advocacy. We started drive-by vigils at the plant. And we did that through the month of May. They had drive-by vigils in Lexington, Grand Island, where there's also plants. We've met with senators, with the governor. We've met with our state representatives. Ricketts...ordered the public health department not to release data.*

Did you confront the governor about hiding the data?

We did, we asked him directly. He had already answered this before, but we wanted to hear from him and see if he had any new information for us. And he said that it was because he believed that people were lying about their employment and where they worked.

That sounds like a pretty thin reason, doesn't it?

It did. We pushed him a little bit on it. We asked, 'Do you have any idea how many people were lying about that?' And he had no idea, couldn't answer. The frustrating thing has been that the governor has been saying he's been relying very much on the University of Nebraska Medical Center to create some guidelines and recommendations, and doing inspections. And he hasn't been turning to the Department of Labor and OSHA, which are the regulatory agencies that can enforce

those things. And so what's frustrating about that is our group has filed OSHA complaints. We've heard from OSHA directly: 'I would recommend that you tell your family member to wear their mask and keep their distance.' That's been the response. 'It's on the employees to curtail this.' We're hearing OSHA pretty much saying, 'Oh, we don't have the power either.'

So who has the power then? He said the company itself is telling employees to social distance, stay six feet apart when it's literally impossible in many of the [work] areas. And so I mentioned that social distancing isn't being enforced. And he said, 'Well, that's employee negligence, because the employer can't sit there and watch them all day.' And so you run into these walls. It's all just coming back to workers all the time. Where's the accountability?

One excellent change to come to the Midwest in recent years is that just above every town the size of Crete now has a good espresso hangout. I found Artisan Mark Coffee + Goods on Main Avenue and waited for Dulce at an outside table. A roar came from the Crete Mills, where corn was being ground. Just as she arrived, sheets of rain started falling. The owner invited us to sit at an inside corner table. There was a sound system playing music. I pulled out my phone and began explaining the story behind the abandoned gas station and the graffito inside. By the time I asked her opinion, chance had it that Bruce Springsteen's "Born in the U.S.A." started playing as a sound track to her answer.

"Prior to the Trump administration, racism existed, but it wasn't so explicit. It opened the door for it to be normalized, to be okay. But it runs much deeper. It's systemic. You think about how much the color of your skin does really impact your lived experiences, your interactions. I'm always very hyperaware of how my race very much affects all my interactions, my experiences. You're born into something that you have no say over, how you'll be treated, how the people around you will respond to your existence. I think some groups are very much disadvantaged even before birth. When my family first arrived

in Crete, we were one of the first Latino families in town. My first experience with racism must have been the letters to the editor in the newspaper. There were a lot of letters at that time that alluded to these 'dirty people' coming. I remember reading those letters when I was younger just thinking, 'This is us they're talking about.' I think America has an infatuation with personal responsibility. And I think, for a white person, it's very much easy to say, 'Oh, that's my problem.' In times like this, it really is true that the rich get richer and the poor get poorer. I think about the meatpacking industry, and how during this time, often workers, safety and their health has been sacrificed in order to for the companies to continue profiting. Last week I saw an article that came out where Kenneth Sullivan—he's the CEO of Smithfield— he wrote an email to Governor Ricketts. The recommendations to wear a mask, keep social distancing—he alluded all of that was causing 'hysteria' among his workers."

The article, in PROPUBLICA, quoted Sullivan's email to Ricketts, written in mid-March:

> We are increasingly at a very high risk that
> food production employees and others in
> critical supply chain roles stop showing up for
> work. This is a direct result of the government
> continually reiterating the importance of social
> distancing, with minimal detail surrounding
> this guidance...Social distancing is a nicety that
> makes sense only for people with laptops.

"And it's just very striking because think about who he is," Dulce continued. "He's the CEO of this company, who obviously can afford a laptop, who obviously can afford to social distance and live at home, and he is the leader for all of these workers who are packed inside meatpacking plants. Do you know how disconnected he is from the actual experience? I always think

that there's a plan for everything. I had never been a community organizer or considered myself an activist. I never thought I would see myself protesting in my hometown. Thinking of just a few weeks ago, when we were all driving out to Smithfield to protest, and it's just insane how we're coping."

Being so new to all this, having been active as an organizer for only a few weeks, Dulce was confused.

"Sometimes I start to question, are we asking for too much? Are we wrong? I think about that sometimes because there's so many voices who want to make us think that we're wrong. I think about OSHA and how some of our claims have been invalidated. I think about the governor and the way that he is with us. In conversations, he's very dismissive. Are we seeing things just way differently than everyone else? They're human rights issues. They're not these crazy ideas. So you start to question your own sanity sometimes..."

I stepped out of the role of journalist—something increasingly easier to do as I age—and pointed out that my students hear this all the time when they write stories critical of politicians or institutions—it was a trick of older so-called leaders to manipulate young people. "Don't let them have that power over you," I said.

"It's been sort of emotionally tolling. If anything, I think workers can realize what's happening, how vulnerable they are and how powerless and helpless they feel. I think the perspective that we as their children can offer, when we've gone on to pursue higher education, we kind of contextualize things differently. And so we help them to see how they and their labor fit into a larger scheme of things. It's definitely changed the conversations I have with my dad. I think he's starting to see things differently. We've all realized that it would be worse not to try to do anything. So, you know, at least there's something happening."

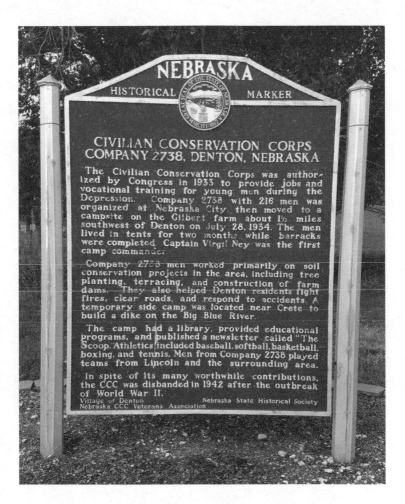

NEBRASKA

HISTORICAL MARKER

CIVILIAN CONSERVATION CORPS
COMPANY 2738, DENTON, NEBRASKA

The Civilian Conservation Corps was authorized by Congress in 1933 to provide jobs and vocational training for young men during the Depression. Company 2738 with 216 men was organized at Nebraska City, then moved to a campsite on the Gilbert farm about 1½ miles southwest of Denton on July 28, 1934. The men lived in tents for two months while barracks were completed. Captain Virgil Ney was the first camp commander.

Company 2738 men worked primarily on soil conservation projects in the area, including tree planting, terracing, and construction of farm dams. They also helped Denton residents fight fires, clear roads, and respond to accidents. A temporary side camp was located near Crete to build a dike on the Big Blue River.

The camp had a library, provided educational programs, and published a newsletter called "The Scoop." Athletics included baseball, softball, basketball, boxing, and tennis. Men from Company 2738 played teams from Lincoln and the surrounding area.

In spite of its many worthwhile contributions, the CCC was disbanded in 1942 after the outbreak of World War II.

Village of Denton Nebraska State Historical Society
Nebraska CCC Veterans Association

Denton, Nebraska, northeast of Crete.

IT'S A WONDERFUL LIFE

When I came home to Denison, Iowa, that Friday afternoon, the Dow back east had just closed for the day and stood at 25,871.46. The week began with the Fed once again doing heroics to prop up Wall Street—on Monday, when the market was tanking because of the rising number of Covid-19 cases, the Fed announced that it would "begin buying a broad and diversified portfolio of corporate bonds to support market liquidity and the availability of credit for large employers." TRANSLATION: *More free money.* The market roared late that day. It was another of the many unusual actions the Fed was taking to prop up the investor class, programs involving municipal bonds, mortgages, commercial paper, and corporate bonds. Each time the market swooned, the Fed threw candy. The action that Monday was the latest scheme to put cash into the hands of companies. Critics said this created the danger of choosing winners and losers. The spirit of Adam Smith was not exactly being channeled. The Fed was helping Wall Street. But who was helping Main Street?

Denison's old-school business district is not on Main Street. It's on Broadway. I always assumed that was an aspirational name. It had been seventeen years since I lived in this meatpacking town of some eight thousand residents, forty-five miles as the Plains raven flies from the Nebraska border. The traditional business district was struggling in 2003. After I checked into my hotel, I drove downtown and walked Broadway and some side streets. The Chinese restaurant, which had food as awful as you might

imagine in a small Iowa town, was stripped inside; a fading FOR SALE sign was in the front window. The biggest missing business was the Topco Drug Store. I knew it was gone, but it was still shocking not to see it. The closing announcement came during my final days in town, when a TWENTY-FIVE PERCENT OFF EVERYTHING sign appeared in the window. Owner and pharmacist Craig Whited told me just before I left that when he'd opened the store twenty-two years earlier, everything was different, that the world of 1982 was not that of 2004 in terms of return. The store saw a 5 percent drop in sales after WalMart opened on the flat land down by the Boyer River in 1992. But Craig battled on, and it became personal when he learned WalMart managers were going through his trash bins to find receipts for information to put him out of business. He grew creative. But near the end he worked nine-hour-plus days, in addition to being on call during the middle of the night. He couldn't sell. Even if he got what the pharmacy theoretically was worth, whoever was foolish enough to purchase the store would basically be buying themselves a middling-wage job that required seventy-or-more-hour weeks. A surprising number of businesses remained, such as Reynold's Clothing. I wondered how that store and the others that survived were faring in the pandemic economy. There were commercial buildings for sale.

I'd come back to town because surrounding Crawford County was now a coronavirus hotspot, twenty-third on a list of the fifty most-infected counties in the United States, as counted by the *New York Times* in June 2020. (Saline County, Nebraska, where Crete is located, was twentieth.) The case rate in Crawford County was 3,362 per 100,000 people. New York City was 3,610 per 100,000. Close enough. I felt a simpatico bond with the people of the county, yet it wasn't just this comparable bleak statistic that made me feel at home. I call Denison "home," but not in the manner one typically describes it. The concept of home has become much more fluid as I've aged. I take the Paul Bowles' approach to life,

DENISON

32 S 14th Street

recently renovated open floor plan commercial building

$127,900

DENISON

19 S Main Street

Turn key business & building

$180,000

that some of us are travelers. Travelers are not tourists and they are not home guards. They are meant to keep moving, albeit very slowly. Wherever we land for more than a passing period of time qualifies as home. I dropped in here for one full year of my life by total quirk. The short version: after 9/11, I was in a bar in Manhattan getting quite drunk with my former editor James Fitzgerald, who had bought *Journey to Nowhere* when he was at Dial/Doubleday. He later became a literary agent. I was being wooed. Jim, who died recently, was one of those insane geniuses who make publishing books interesting. In the wake of the terror attack, he said *A book about a small town would be hot right now.* We scrawled ideas on a napkin. A week later, my phone rang. Jim told me that an editor at a big publishing house said he wanted a book about a small town. *Funny you should mention that*, he told the editor. I ended up with a six-figure advance to write about a town that I'd never been to. The editor who bought the book was fired a week after the deal was struck. It meant I was "orphaned" in publishing-speak, and I'd been in the game long enough to know it meant the corporate house would do zilch, nada, jack shit to promote the book. But it didn't matter. I wasn't against taking the Man's money.

I had to find a town. I wanted a small one, with immigrants. With meatpacking plants. I went online and clicked through some half dozen small towns. When I opened the city of Denison official site, a picture of the water tower came up. On it was written: IT'S A WONDERFUL LIFE. Donna Reed, who costarred with James Stewart in the Christmas film classic of that name, grew up here. I then discovered two more facts: there were about three thousand Latinos in town, one-third of the population. And that the previous fall, a grain car was pulled from storage in Oklahoma and brought to the grain elevators of Denison to be loaded. A worker opened one of the hatches and smelled an odor. When he peered inside there were eleven mummified bodies—the remains of immigrants being smuggled by a coyote back in June on the Texas border. Someone never opened the hatch to let them out.

The influx of immigrants to the Midwest began over a decade earlier, after the meat-processing companies broke the unions and sped up the workflow, which caused whites to head for the exits. Denison, like many of the towns with newcomers, was experiencing tensions. I made a few calls. The discovery of the eleven mummies had intensified soul-searching in the community, I quickly learned.

I packed my things and drove to Iowa. Jim, who had weird ideas that somehow always made sense, told me to first visit the cemetery to discover who had the largest monument. He felt it would speak to me. After checking into a cheap hotel, I immediately drove out to the cemetery. The name "Shaw" was on a mausoleum, the largest marker of sorts in the graveyard. Three nights later I was sleeping in the rotting mansion that had belonged to Leslie Shaw, governor of Iowa and later secretary of the Treasury from 1901 to 1907 in the Theodore Roosevelt administration. The ballroom above my quarters had recently been a meth lab. The house was haunted. That winter the ghost made their presence quite known.

That I was in the mansion was due to Nathan Mahrt, a Denison resident, middle school industrial technology teacher, town seer, and de facto local historian. Nate had connections to the owner. He would tell me that Denison chose me, that I did not choose it, a recurring theme in my life. In the year that I lived there, I immersed in everything: the Latino workers, the business community, local politics, and in general, everyday life in a small Midwest town. It echoed a latter-day real-life *Winesburg, Ohio*. After I moved away, Nate was elected mayor, in 2005. The vote count was 1,076 to 733.

Nate and I kept in touch. As a politician he continued grappling with the problems I'd documented. There were two kinds of whites in Denison: those who disliked the immigrants and those who saw them as an infusion of new vitality in what otherwise would be another dying Midwest town. Nate was in the latter camp. On February 28, 2017, he sent me this email:

I live in Trumpville. These people have no idea
that without immigrants the local economy
would be gone… Everyone is a suspect again.
Sad state of affairs: free press is a hallmark of
our democracy and they are now in the mud.
We are on a slippery slope here. Thinking
Belize…Cuba is too close.

When we met in his backyard, Nate and his wife were still thinking of moving to Belize, or their new favorite, Portugal.

"See, when you were here, there wasn't any talk about sending people back. The thing with Trump, when he got elected and started with that horseshit, we went from Dreamers to 'We got to send those bastards home.' There was a huge change," Nate said. Latinos began selling houses. There was a noticeable slowdown in immigrants looking at the long term. "They don't want to invest because they feel like they're going to get kicked out any day now. So that hurt 'Main Street.' They're not spending their money here, because they 'don't belong here.' And you wouldn't believe the night-and-day difference with my kids at school. A lot of them see their future in Mexico. They don't see it here. They want to get educated here, but they're going back to Mexico. The future is down there. Their future is not here anymore."

This was the backdrop when the pandemic struck. The town was already hurting from the immigrant bashing filtering down from the White House. Nate fears the economic impact of the virus will be the next crisis to hit the city. People who were patronizing the businesses on Broadway had been buying things online since stores were ordered closed.

"People that weren't online before are now online. They're even shopping at Walmart online. I've talked to quite a few people that buy stuff online and go pick it up, because they don't

Nathan Mahrt.

want to walk through there. So who gets rich out of this? Jeff Bezos and Walmart. Like they planned it."

He pointed to Reynold's Clothing on Broadway. It was mandated to be temporarily closed. But WalMart was not because it sold food. I saw this in California. People were at Target not to buy groceries but clothing. I found it odd that clothing stores weren't allowed to be open with proper social distancing.

"It was really ridiculous, the fact that you can't buy a shirt at Reynold's but you can go out to Walmart and buy one," Nathan said. "I want a shirt, I want to go to Reynold's. But I can't buy a shirt at Reynold's. So I'm gonna go on Amazon." When I lived here, Nate always called WalMart "Satan's Hollow." He feared that people would switch habits, which could doom Reynold's and other businesses struggling to hang on. "It's not going to be what it was before Covid. That number will never come back."

The pandemic will hit cities such as Denison in other ways, such as a substantial drop in sales tax revenue because of online shopping and more stores going under. Iowa doesn't have a local option sales tax—that is, cities are forbidden to raise them any higher than the 6 percent allowed by state law.

"Because you don't have the local option sales tax, you're relying on property tax. Government will not shrink. So our property taxes are going to go higher. Property taxes going up, it's going to hit retired people. It's gonna hurt workers at the plant."

I wondered if people would rebel if property taxes escalated. Nate laughed sardonically.

"You forget that we're very passive aggressive. The 'Iowa nice,'" he said of the truism I witnessed many times. People will smile to your face but curse bitterly about you behind your back. But if people were to get angry, it would mean facing choices.

"In the next couple of years, we're going to come to a point where we're going to have to decide: What do we need? And what do we want? We want all these things, but what do we need? Because we don't have the money for the wants. Do we need a conference center?" he asked of the Boulders Conference Center, built and maintained by the city at great expense. "Do we need fifteen cops?"

When I wrote about Denison, I posited that Denison was a microcosm of America. And it remains so. These are the same questions being asked in New York City. Does the NYPD really need thirty-six thousand sworn officers on its force?

"Property taxes are going higher unless they cut things," Nate said. "So do we need fifteen police officers? Or do we need seven? They want to have two people on duty at all times. That's what they want. But we're going to have to start deciding whether we need things."

As we talked at a table in his side yard, there was a roar coming from the distant Smithfield Foods plant. When I lived here it was Farmland Foods, and as many as 9,400 hogs were processed there each day.

"In the middle of April, sometimes I'd come out here," Nate said. "It would be completely quiet. You could hear birds three blocks away. People weren't showing up for work. There were days when there were like four hundred people there. They're supposed to have 1,800. But they were scared Covid was going to kill everybody. If workers did not miss a day of work at Smithfield, in the month of April, they got a $500 bonus. What are people going to choose?"

Smithfield called this a "responsibility bonus," to be paid if workers finished each shift during April. In a statement, the company said it was part of an initiative called "#ThankAFoodWorker." "Employees who miss work due to Covid-19 exposure or diagnosis will receive the Responsibility Bonus." But that wasn't the point—the money was to lure the

workers back into the plant, where they could become sickened. "It's ridiculous," Nate said. "I do hope somewhere down the line, someone comes across with some sort of sanction for them."

Billboard, U.S. Route 24, Peru, Indiana.

VI

YOUNGSTOWN

I'M SINKING DOWN

The time has come to bid a farewell.
I started here Dec. 5, 1973, 11/7
shift for Republic Steel just being a young
man having only the desire to make
a little money and then leave to become
a mountain man. I came here
looking for a job. But what I found...
the ability to help my mother, raise 3 sons,
roof over my head, food on the table,
clothes on my back, a lifestyle that's
good, meeting a lot of great people, making
new friends, accomplish what they
said couldn't be done, learning from other
older men, constantly using my mind,
pushing myself and somewhere or somehow
making customers happy.

I now leave looking & hoping
to find a place that employs me for
my service. But the amazing
thing I have ran across
is people's attitudes, when
it came to work. There
is no use for me to go
into great details or blame
of why a company or business
fails. No government can pass
a law to help it survive.
No contract can guarantee
employment forever.

Bill H—
4/27/03

This was written on a green chalkboard, inside the ruins of Republic Steel's Hazelton Works in Youngstown, Ohio, shot by documentary photographer Paul Grilli in early June 2020.

From my field notes while working in Youngstown, August 2018:

> —*GM just laid off 1,400 from Lordstown. Hospital closed, more than 1,000 laid off.*

> —*Standing with mom of friend off steel street. Carnegie House. Dark smoke. Nervous. Houses still burn all the time. Some things have not changed. Worried another house going up. But just a junk fire next to house. Kid shot on porch two doors down. Drug related. But it's not so bad. they say.*

> —*Everyone smokes. Lots of nervous energy in Yotown people. Guy off steel street in and out of truck. Woman rocks a lot on feet. Smoke Smoke Smoke. Newports.*

> —*"Opioids is part of the culture here. Inescapable."*

A formerly addicted small-time dealer shows me how
he made heroin packets to sell in Youngstown.

HOODS

—The eight. Warren. After first digit in phone.

—Area 51. Combat zone. Hookers. Drugs. Around USWA 1375. Adams and Atlantic.

—"Y-town."

—Klanfield.

—Poland cops assholes to any outsiders. Especially blacks. You will be stopped.

Translation/explanation: On March 6, 2019, General Motors permanently closed its Lordstown plant, just northwest of Youngstown; the last 1,500 jobs wiped out. One house on average per day burned when I was reporting in Youngstown in 1983. They were still burning; I was talking to a woman near where the Ohio Works stood and we saw smoke and it scared her, until we found it was a neighbor burning brush. The population dropped from a peak of 168,000 to 65,000. United Steelworkers Local 1375 represented workers at the last fully integrated steel mill in the Mahoning Valley; the Warren mill was demolished in 2017 when the final blast furnace in the valley was toppled for scrap. "The Eight" is a neighborhood in Warren, to the north of Youngstown. "Klanfield" is local slang for Canfield, where a lot of conservative white people live. Poland is a town south of Youngstown.

Rip's Cafe, Struthers, south of Youngstown, in 2018.

A bumper sticker, pasted to a locker in a dead steel mill, that I curated in 1983.

There's the new downtown Youngstown, built in part on socialism for private enterprise. It started with the Covelli Centre, a multipurpose arena that opened in 2005, made possible by a parting gift from Congressman James A. Traficant, the mobbed-up former local sheriff I interviewed in 1983 (*I've been inside the belly of the beast, Dale...and let me tell you, it stinks!*), who was convicted on federal corruption charges in higher office and sent to prison. In one of his final acts in Congress, Traficant landed the city a $26 million HUD redevelopment grant to fund the arena. It was bookended in 2018 with the rehabilitation of Youngstown Sheet and Tube's onetime headquarters, the historic building transformed into a four-star DoubleTree by Hilton. The project got a $2 million bridge loan from officials, with money questionably transferred from the city's water and wastewater fund. There was a ten-year 75 percent tax abatement and $9 million in federal and state historic tax credits. Amid this emerged venues such as the V2 Wine Bar and Trattoria, Ryes Craft Beer and Whiskey, the Funny Farm Comedy Club, and a loft-style complex:

The Wells Building
Luxury Downtown Youngstown Apartments

"Rents start as low as $950"

As the newest member of the highly acclaimed
"Tech Block," note that the Wells Building is one
of the only residential properties in the region to
offer hi speed dedicated fiber on site. Each unit
has professionally designed interiors with spacious
living, dining and bathrooms highlighted by 12 foot
high ceilings and an abundance of natural light.

Youngstown is the kind of place that if you have repeatedly visited over the course of the past nearly four decades, you don't

pay attention to the beautiful corpse that is the new downtown, along Federal Street and its environs. You notice what's missing, retain the memory of what once was: The neighborhood that had dozens of homes but today is a vast meadow. Steel mills stretching for a dozen miles along the Mahoning River (and the fifty thousand high-paid union jobs associated with them,) vanished; the flats along the banks of the river returned to nature, thick with maturing riparian forest. The commercial strip of mom-and-pop businesses, disappeared; if you walk in the brush you find bricks and twisted pieces of metal, like remnants of a lost civilization. The parking lot of the Lordstown plant, visible off the Ohio Turnpike, always filled with hundreds of workers' cars for all three shifts, the latest body blow—today just acres of empty asphalt.

I first came here in 1983, and I've returned many times over the years. My guide has always been Dr. John Russo, an emeritus labor studies professor at Youngstown State University, joined along the way by Dr. Sherry Linkon, a professor of English and director of the writing program at Georgetown University. Sherry edits Working Class Perspectives, a weekly blog, and she was the founding president of the Working-Class Studies Association. For years, Sherry also taught at YSU. John and Sherry are married as well as partners in studying working-class issues. They cowrote *Steeltown U.S.A.: Work and Memory in Youngstown*. In 1983 John predicted that Youngstown would not only become the poster child of deindustrialization—he said the rest of the United States would become Youngstown in terms of stunning class disparity. He was correct. In 1995, John said the deep and bitter anger that pulsed through the remaining white population of Youngstown and its environs was dangerous; he looked at history and predicted what would happen.

"It's not unlike the anger in prewar Germany and prewar Italy," I quoted John saying. In the United States, capitalists allowed themselves to be saved by President Franklin Roosevelt.

John feared that the anger would turn toward right-wing hate, I wrote. "There is the old famous line by the [Communist Party]: the worse it gets, the better it gets. Now the reality is that the worse it gets, the worse it gets."

I actually toned down his fears in my book. They seemed so far-fetched, the inevitability of the American people electing a demagogue and authoritarian. He was, of course, correct, and twenty years early with his prediction.

And so, as I pulled up to what was now their summer home on the north side of Youngstown, I was eager to hear both what he and Sherry thought of the pandemic economy and what it meant for the 2020s. We sat in their backyard, beneath a towering 150-year-old red oak with a trunk that had a circumference of fourteen feet.

One big change locally was that for years, the suburbs were inured to a degree from the devastation that whacked Youngstown inside the city limits.

"Just go out to Austintown and Poland and Canfield and what are you going to see? Large numbers of houses for sale," John said. "Austintown was built because of Lordstown, in the 1960s. All through this area, you see this sort of emptying out of the suburbs because people don't have money. They're going to food banks. You can see the cars lined up in Pittsburgh. They were showing that on the news one night, the line up for cars going to the food bank there. They were not jalopies. There were very nice cars."

"We're facing some real challenges," Sherry said. "and I think those are going to be with us for a long time and that it will feel like a depression. Hundreds of thousands of people are going to lose their homes."

John doubled down on his 1995 prediction—he feels the threat from the far right will not abate. "My view is that Trump's going to get beat. And the thing I say is, 'So what?' Right now we are at a tipping point in terms of what the American economy is going to look like, what the American social structures are going to look

like, what the urban landscape and suburban landscape is going to look like."

John said, "2024, that's going to be the seminal election." The economy will be devastated, there will be trillions of dollars of debt accrued from the Federal Reserve printing money, taxes will have to increase. There will be a fight between progressives and right-wing authoritarianism between 2021 and 2024. He fears a strongman will win.

Sherry disagreed. "I am by nature much more optimistic than John. As horrible as the Great Depression was, a number of really amazing things came out of it," she said, citing the creation of programs such as Social Security. She sees the potential for a new progressive shift that repeats in the 2020s, led in large part by Black Lives Matter. "People are not just sitting back going, 'Give us a dictator who's going to fix everything.' There's a very strong pushback." She does worry, however, that BLM could fizzle just like Occupy Wall Street.

"Where Sherry and I agree," John said, "is that I think 2021 to 2024 is going to be a contested terrain. You're having the death of one type of system and the beginnings of something else. We don't know exactly what that's going to look like."

The desert pictures on my phone felt very far away from this pleasant spot with Sherry and John, and yet the desolation was familiar. Robins cried from somewhere up in the branches of the massive red oak. Distant thunder came from the west.

"My reaction to it is that's the graffiti version of a lot of the novels that I wrote about in my last book," Sherry said, citing her 2018 book, *The Half-Life of Deindustrialization: Working-Class Writing about Economic Restructuring.* She examined novels, short stories, films, and poems created by the children and grandchildren of the working class. "For a long time, people who studied deindustrialization talked primarily about the experience of having things close down. Part of what I wanted to talk about was what I call the 'half-life of deindustrialization,' the fact that

their children and grandchildren are born into it. That's their reality, all of their lives...There's a sense that 'we were screwed from the beginning, we were fucked at birth.'"

"That's one side of it," John said. "We don't know who wrote that. If it was a younger person, that reflects exactly what you're saying. Or it's people who have been fucked all the way along."

"I'm skeptical that would be from an older person, in part because the analysis would be 'I did everything right, now I'm screwed,' which is different from 'it was messed up from the time I was born,'" Sherry said.

John was the first person to address the American flag on the exterior of the abandoned gas station.

"The juxtaposition really brings into relief the discussion of the American dream, where it is right now. Or is it the 'American nightmare,' to use the language of fifteen years ago? There's a type of nihilism that gets played out. It's dark. This is another 'now what?' You know, the American dream: I get my education to do all these wonderful things, and it didn't turn out the way it was supposed to. Now what?"

"It was 'if I got a college degree I would be fine.' I feel like a huge part of my teaching at YSU was about trying to teach my students that the dream was flawed and that they were fucked at birth," Sherry said about instructing the children and grandchildren of onetime steelworkers. "They pushed back against it. To be a college student, you kind of have to say, 'No, I can overcome this. I'm going to work really hard. I'm going to invest my time, I'm going to save my money. I'm going to do everything right to try to get out of this.' They used to get really mad at me, because they would be like, 'Everything you're telling us is that there's no hope for us.' And I would say to them, 'It's not that I think there's no hope for you. It's that I want to make sure you understand that if things don't turn out well for you, there's a really good chance it's not your fault. It's not because you didn't try hard enough. It's not because you're not smart enough. It's because the system

is screwed.' They don't want to blame the system. For young people, they have to believe that they have power in their lives."

As a hard rain began to fall, and we retreated to the interior of the house; I worried about the danger of the virus. I sat far across from the couple on the couch—we were in mode, the virus be damned. I flashed to a conversation with John in 2018. Sherry was still in Washington that year when I met with John, who said there might be an inherited reason for what I would see in the graffito in that abandoned desert gas station two years later. I was in town doing research for a fictional podcast that involved, in part, the huge number of opioid overdose deaths in the Youngstown region. I met up with John that summer and asked about this crisis.

"Epigenetics," John announced.

Darwin of course came to dominate evolutionary theory, but Jean-Baptiste Lamarck appears to have been partly correct—some traits are inherited. A study by Kerry Ressler, a neurobiologist and psychiatrist at Emory University in Atlanta, used lab mice to prove Lamarck's theory centuries later. Mice were presented a smell, acetophenone, which is akin to cherries and almonds, at the same time they received weak electric shocks. The mice learned to associate the scent with the shock, even when no current was applied. The mice were bred. Their offspring and grandchildren mice also reacted to the smell—even when bred in vitro. There appear to be receptors on some DNA that "learn" trauma. It was second-and third-generation offspring of the steelworkers who were overdosing.

"I wondered how they are different from the people that I saw in the eighties," John said of the victims of suicide and domestic violence that followed the mills shutting. Epigenetics, combined with stress in their homes when growing up, explains a lot, he said. Nature and anti-nurture. "Nobody was talking about how all that stuff gets internalized in different ways, and then it gets played out over the second generation. People have given up,

and so they just self-medicate themselves and go away. It's the erasure of identity. Erasure of community and participation in community."

During one visit to Youngstown in 2009, I was seeking hope. I found Ian Beniston, who was born one month before I arrived that first time in March 1983 when the steel mills were shutting down. His father was among the 3,500 workers who lost their jobs when U.S. Steel's Ohio Works closed. Ian grew up and went away. He'd returned not long before we met, looking to heal and transform his hometown. He had a plan to rehabilitate ruined neighborhoods by fixing homes, and demolishing those too far gone. He told me there were three kinds of people in Youngstown: old-timers who believed the mills would return, the defeated, and those like him, thinking about reinvention. He was realistic. He started with one neighborhood, Idora, not the entire city. Out of this emerged the nonprofit Youngstown Neighborhood Development Corporation (YNDC). When I returned months later in 2009, things were already looking better. Homes were being worked on. Vacant dwellings were being demolished and empty lots replaced with urban farms.

When I phoned Ian before I began driving across the country in 2020, I asked for his take on the state of Youngstown after the closing of Lordstown and the pandemic economy.

"That's a difficult question," he said, chuckling disconcertingly. "For us, things will be tough, as they always are. It's not going to be easy. Your buddy John Russo says we should just wither on the vine and die. He says there's nothing we can do."

John was standing near Ian that morning when I pulled up to the YNDC's headquarters, now an expansive operation with a fleet of trucks, a bakery, a headquarters powered in part by several arrays of solar panels. There are twenty full-time employees, funded by a combination of grants and rental income

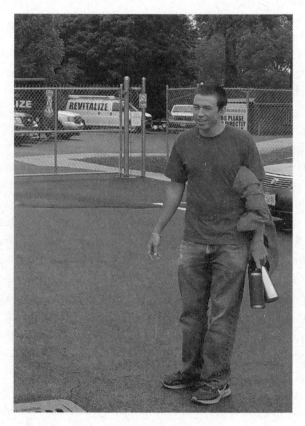

Ian Beniston outside the gates of the Youngstown
Neighborhood Development Corporation.

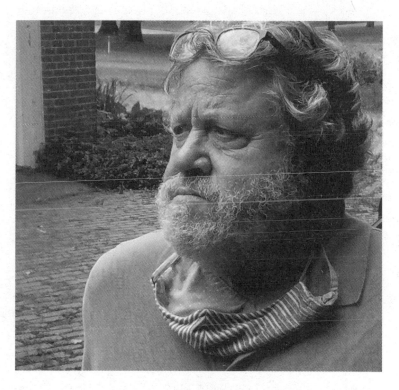

John Russo.

from refurbished homes and apartment buildings. Since I'd been there in 2009, the nonprofit had renovated 150 vacant buildings and repaired 500 owner-occupied homes. In addition, Ian said, "We've done many other basic neighborhood things: replacing sidewalks, fixing city parks, planting hundreds of trees, and cleaning up thousands of vacant properties." In 2009 there were 4,578 abandoned structures. There are now 1,800. A city plan embraces "smart shrinkage," saving some neighborhoods that are still vital, letting others become meadows.

Ian confronted John, who asked to tag along this morning as Ian showed me around. "You said we should pick up and leave, Youngstown should shut down," Ian said. As the men went back and forth in debate, I thought of it as not so much a discussion between a young man with hope and an older man who sees some deeper dark reality; There was something else going on.

"You think I don't say good things about Youngstown," John said, "but you're so dead wrong."

John said he and Sherry were invited to a World Bank meeting, to talk about deindustrialized communities. "There were people studying the mining industry, in West Virginia, South Africa, and Poland, and how are these communities going to survive? One guy finally said, 'I think we should all just give up and move them to other parts of the country.' And I said, 'Well, what about reclamation projects?'" John said he extolled what Ian's nonprofit is doing. But then John added, "I don't know if that's going to be economically feasible in the long run. If jobs don't come and stay here, we're going to get hit." He said the pandemic economy is making it even more difficult. "A lot of people in this neighborhood are in the service industry. Are those guys going to get their jobs back in retail and service? It's a fight to maintain place and space, and it's going to be much broader now. Because Youngstown's story continues to be America's story."

Ian's response was Zen: he can't fix America. But he can fix the Idora neighborhood and a few others, controlling what he

can grasp. The nonprofit didn't have the means to bring in new industries or other jobs. But he could make the city appealing. "I was just telling John before you arrived: we have to get the basics on track here. Why the fuck would you put your company in Youngstown when we can't get the grass cut? We can't get the potholes filled? I think the advantage of the pandemic is that it's again showing people that location doesn't really matter when it comes to employment." He noted that two different people came from California, buying in the Idora neighborhood, to escape the high housing costs of the West Coast; one lives in a mansion.

When we put on masks and got into John's car with open windows and with John at the wheel, Ian pointed to numerous homes the nonprofit has fixed. Some were brick, some quite large, with hardwood floors and fine woodwork. The neighborhood borders 4,500-acre Mill Creek Park, with ponds and deep woods; it has a bucolic feel. (A stately four-bedroom, three-and-a-half bath home on three-quarters of an acre next to the park was listed for exactly $100,000—it would cost well over $1 million in coastal California.) "You can buy a house in this neighborhood from $60,000 to $90,000. If we can create a high-quality community, there are assets here to build from. Our strategy is to kind of chip away incrementally."

Some serious problems are beyond the power of the nonprofit, Ian said. "I don't have all the answers. What I do know is that lots of our residents don't have skills to do anything. They don't have a driver's license, they don't even have a basic high school education." There are societal issues that must be addressed. "In some census tracts here on the south side, 50-plus percent of working-age Black men are unemployed. Why is that?"

One effort to employ residents that the nonprofit tried: urban farming. It failed. YNDC is no longer doing that. "It's just not an employment generator," Ian said. This was disappointing: in so many inner-city areas, it seemed like an attainable solution for at least some income. Ian said the problems are many: scale

is impossible because lots are so scattered; it's labor-intensive; there's too much open farmland just outside the metropolitan area. It's not New York City. Lots ended up weed-choked. "When it comes to vacant land what I tell people is plant grass and plant trees, because it's a lot easier to cut the grass."

We talked about the widening gyre of decay in the suburbs. The housing stock in Austintown near the closed GM factory is mainly nine-hundred-square-foot slab tract homes built in the 1960s. Ian said there is no saving them. The specter of rotting abandonment in the suburbs looms. "What we're doing here in Youngstown really should be happening throughout the six-county region," Ian said. There's ruin all over—in nearby Sharon and New Castle, Pennsylvania; to the immediate north, in Warren; south along the Mahoning River; down on the Ohio River. "East Liverpool," Ian said, "half of it looks like a bomb went off."

Ian has no bandwidth—or funding—to go beyond his focus neighborhoods and some other parts of Youngstown, to reach out to do work in those other counties. Idora is thirty square blocks. There are a few other neighborhoods the nonprofit is working in. But Idora is the heart of its mission.

Later, near the end of our drive, Ian beamed. He saw beauty through the windshield in the neighborhood that he had control over. He pointed: "You'll see, as we go around the corner, why we built the new houses here. The rest of this neighborhood's pretty much fully intact. So we didn't want to have a street that had nine or ten vacant lots, because we had to tear the houses down. This is actually quite nice. You'll see as we go through here..."

VII

IF '20S ARE '30S

IF '20S ARE '30S

When the republic grows too heavy to
endure, then Caesar will carry it;
When life grows hateful, there's power...

—Robinson Jeffers, "The Broken Balance,"
quoted in James Rorty's *Where Life Is Better*

Shortly after 2 P.M. on February 27, 1935, James Rorty, age forty-four, was escorted to the eastern Imperial County line in California by sheriff's deputies. He was passed into the hands of Arizona law officers. He'd spent the night in jail after being arrested on suspicion of engaging in communist activities. Rorty was described in a *Los Angeles Times* news account as a "frequent contributor to the reviews and author of the recent book 'Our Masters Bay,' a study of advertising...Rorty said he was touring the country as a correspondent for the New York Evening Post and a contributor to the Nation, a liberal weekly published in New York." The following day, near Yuma, Arizona, another brief story said, "An attempt by Rorty...to inspect the transient camp maintained by the Arizona Welfare Office, five miles east of here, was blocked, according to officials."

Rorty's travels that year were collected in a book, *Where Life Is Better: An Unsentimental American Journey*, published in early 1936. He spent months talking with farmers, workers in the steel towns, coal miners, and famous people such as Robinson Jeffers and Louisiana senator Huey Long, not long before he was assassinated.

Rorty was bitter, perhaps more so because of his treatment by the Imperial County sheriff, after his journey into the heart of Great Depression America. In the preface, he wrote of what he heard:

> Business would "pick up." Life would be better just over some nearing horizon of space or time— not different, but "better." With few exceptions the hitch-hikers I picked up along the road shared this day dream equally with the secretaries of the local Chambers of Commerce...I encountered nothing in 15,000 miles of travel that disgusted and appalled me so much as this American addiction to makebelieve. Apparently, not even empty bellies can cure it. Of all the facts I dug up, none seemed so significant or so dangerous as the overwhelming fact of our lazy, irresponsible, adolescent inability to face the truth or tell it.

Rorty, a World War I veteran with PTSD, despised Franklin Roosevelt's New Deal. He called it "fake reform." Everywhere he heard people talking about war as an answer for the nation's economic ills. War meant jobs.

> The 95 per cent don't know the questions. But they know the answer, know it in their bones. "I guess things won't get any better until we have another war." How many times did I hear that all across the continent and back!...These people, the 95 per cent, were untouched by socialist, communist, or pacifist educations. But they know the answer. Not that they were for it, particularly. They were merely resigned...A war would solve it, they felt, even though some of them perceived vaguely that a war would only postpone and deepen the ultimate disaster."

The Rorty work is one of a number of nonfiction books published in the mid-to late 1930s, chronicling road trips around America. Among some of the others: *Puzzled America*, by Sherwood Anderson, 1935; *America Faces the Barricades*, by John Spivak, 1935; *You Have Seen Their Faces*, by Erskine Caldwell and Margaret Bourke-White, 1937; *My America*, by Louis Adamic, 1938. (I exclude *Let Us Now Praise Famous Men*, by James Agee and Walker Evans, 1941, researched in 1936, from this list. It was not a travel book; it was about three sharecropping families living on one hill in Alabama.) This is not a definitive accounting; they are some of those I read.

Each of the authors try to capture the mood of a nation by talking with and showing readers a range of Americans. They vary widely in quality. At the bad end of the spectrum, the Caldwell-Bourke-White collaboration is the worst. Many photographs have an exploitative feel, and the volume is filled with cringeworthy captions of unnamed people saying things like, "I got more children now than I know what to do with, but they keep coming along like watermelons in the summertime." Second worst is Anderson's book, which one wonders may have prompted Rorty's subtitle. It's sentimental. When I began reading it many years ago, I simply couldn't finish. The *Washington Post* review said *Puzzled America* "could scarcely be more cheering to Roosevelt and cohorts if it had been turned out by an alphabetical bureau of press information." The *New York Herald Tribune* wrote of Anderson:

> There is not a single word about the Southern textile strike, nothing about the terrorization of the Negroes, nothing to indicate that Huey Long has already, to all intents and purposes, established a Fascist state in Louisiana... When he reflects, he enters a cloud-cuckoo land of bewildered musings. "Puzzled America" is an apt phrase to describe the psychological state

of the country. But there is puzzled Sherwood Anderson.

The finest, in sections, is the now obscure Adamic work, though it is really two books in one: the first being a memoir about his being an immigrant in America; the second concerning the Great Depression. Adamic's portrayal of the country in hard times is deeply reported and beautifully written. There are numerous dispatches that if read aloud sound like a contemporary podcast. Among the best chapters is "The Great 'Bootleg Coal' Industry," an assignment for the *Nation*, in which he chronicles jobless coal miners and their illegal pits—tiny mines dug by hand with shovels, on company lands in Pennsylvania—and their selling the "stolen" coal on the black market in New York City. In the following chapter, "Notes on the 'Communists' and Some American Fundamentals," Adamic documents a group of idealistic young Communist organizers from New York City who came to transform the rural coal bootleggers into revolutionaries. Their comedic failure illustrates that the Union Square "riot" of 1930, which prompted American capitalists to fear a U.S. version of a Bolshevik revolution, was never going to happen. But it was that fear that gave FDR leverage to save capitalism from itself. If Adamic's book had received wide distribution on Wall Street, FDR might have failed.

Yet the "threat" of communism coming to the United States remains imprinted in the narrative many Americans have from the history of that era, though this was displaced somewhat by Philip Roth's novel *The Plot Against America*, later an HBO miniseries, in which aviator-hero Charles Lindbergh is elected president and tilts the country toward fascism. The Roth novel shows the reality: the energy turned from the Left to the Right as the 1930s matured. As Rorty wrote in his 1936 book: "Our domestic situation as that of a progressively deteriorating social and economic anarchy, with a definite drift toward fascism."

These books and some articles from the 1930s were in my head as I drove east from California during the pandemic. There are, of course, limitations to this kind of work. I saw and experienced only what I was able to set up by pre-interviewing people, later meeting them, and what serendipity delivered. It was a short journey, just some two weeks. But there is a weight of reporting from the years leading up to my quest to seek answers about the graffito. Since 1982, my guess is that I've traveled about five hundred thousand miles around America listening to people for the articles and previous books I've published. Since I began teaching in 1991, I've told my students in my social issues narrative reporting class—both at Stanford and Columbia Universities—that it's wise to study the 1930s. Now that we are entering what appears to be this century's 1930s, knowing a little bit about that decade truly seems in order. I don't know what is going to happen any more than did Rorty, Adamic, and the others as they explored the nation between 1935 and 1938. But if the cliché of the past being prologue holds true, knowledge of that decade may prepare us for what's next, especially in the critical years between 2021 and 2024, as pointed out by John Russo and Sherry Linkon.

There are parallels and differences between the work of the 1930s documentarians and my recent trip across the country, as well as others I've taken.

Like Rorty, in the early 1980s, I constantly heard people say that perhaps a war would make the economy better. That petered out as that decade ended. I've never heard this in recent years.

I heard optimism when I rode the rails with new job-seeking hobos in the early 1980s. That too changed as the 1990s became the 2000s; the sizable majority of those I've met feel that life won't get better for them. And in the last two decades I've not come across people traveling to look for permanent work, just

those on the circuit of seasonal warehouse jobs. The displaced rubber tramps and van dwellers know life is not going to be better somewhere else. Rorty would likely have been pleased with this pessimism, but the absence of this hope in the modern era is most troubling.

The only thing my findings have in common with Sherwood Anderson's: self-blame. Everywhere he went he found people who said, "I've failed in this American scheme. It's my own fault." And "It's my own fault. I was not smart enough." I heard similar sentiments in the homeless camps of Sacramento in 2020 and in other years.

A constant in all eras: fear about the economic future.

The economy will form the contested terrain in the years 2021 to 2024. The hoped-for V-shaped recovery, in which the economy would bounce back at the cessation of the pandemic, clearly isn't going to happen. The question is if it will be a U, which is an uphill recovery that occurs slowly, or a big D.

We've been overdue by two or so decades for a depression, if one adheres to the long-wave theory, posited by Nikolai Kondratiev (or Kondratieff), a Soviet economist. His theory holds that capitalist economies look like a decades-long roller coaster—they ascend in a boom, hit apex, and then come way down in a bust. Kondratiev documented five of these long waves dating to the 1700s. Each cycle lasted forty to sixty years. Modern economists dismiss Kondratiev, who died in prison under Stalin in 1938. Yet Kondratiev is surfacing more and more in conversation. Robert Samuelson, a business and economics columnist for the *Washington Post*, wrote in the early summer of 2020, just before he retired,

> I regarded Kondratieff's long waves with scorn and skepticism. The long waves seemed, at

best, too long and too diverse to qualify as a genuine economic cycle. At worst, they were junk economics, a clever idea that, the more it was examined, the more it would be found wanting...I haven't joined the Kondratieff camp just yet. But I am a lot more open-minded. What I do know is that the existing framework of economics has not served us particularly well... We are at a dangerous moment.

If we are entering Kondratiev's valley, the danger would be to assume that things will turn out with some form of progressive populism prevailing in the wake of Donald Trump. A bad economy with deep unemployment could result in a battle between progressive populism and an authoritarian who capitalizes on dark populism. If an uncrazy and smart Trump comes along, he or she could eclipse the threat that Trump presented to American democracy.

We think of Twitter and other social media, along with Fox News and the One America News Network, as being drivers of far right ideas such as QAnon, amplifying feelings and actions that heretofore would have remained in the shadows. But long before there were social media platforms and television, right-wing and fascist ideas thoroughly infiltrated American culture. An early activist who recognized how these ideas spread was the Reverend L.M. Birkhead, a Unitarian minister from Kansas City. In 1935 Birkhead traveled to Europe to investigate the authoritarian governments of Italy and Germany. In Nuremberg he went to the offices of *Der Stürmer*, the anti-Semitic newspaper that was a core distributor of Nazi propaganda, whose founder and publisher was Julius Streicher, a fervent anti-Semite. Streicher, a favorite of Adolf Hitler's, would later take part in giving orders during

Kristallnacht in 1938; his moment in the klieg lights of hate would end with his hanging by the Allies at Nuremberg Prison in 1946.

"I had come...to discover there were anti-Jewish groups and leaders in America about whom the American public does not know and American anti-Semites who hope through Streicher's help and inspiration to duplicate his plans and technique in the United States," Birkhead wrote in a dispatch for the *Baltimore Sun*.

In 1938 Birkhead released a list of eight hundred "anti-democratic" organizations in the United States that were aligned with the Nazis and fascism. He maintained one out of every three Americans was being reached by fascist materials, some of the propaganda coming from Germany. The social media/television equivalent of that day was radio, a new technology that became widespread in the 1920s. By the 1930s the Reverend Charles E. Coughlin, a Catholic priest, became the first far right media star in America. His radio hate ministry reached 10 million listeners in 1934. In 1938 his show used anti-Jewish propaganda and made false claims. I wrote about what happened next in *Someplace Like America*:

> In New York City, radio station WMCA declared
> that it would no longer broadcast Coughlin
> unless he provided an advance script. He refused.
> In Germany, the Nazi press rose to Coughlin's
> defense, and a headline in the newspaper
> *Zwoelfuhrblatt* blared, "Americans Not Allowed to
> Hear the Truth."
>
> A new organization had begun to form,
> dubbed the "Christian Front," in opposition to
> the "popular front" organizations of the left.
> The Christian Front attracted anti-Semites.
> On December 15, 1938, six thousand people
> gathered in a New York City auditorium to cheer
> Coughlin and boo Roosevelt. On December 18,

the Christian Front organized two thousand "Coughlinites" to march on WMCA.

Up to this point in the Great Depression, observers had warned of an emerging fascist trend in the United States, but there had been little evidence of mobilization. Now, violence began.

Coughlin called for the formation of "platoons." On May 21, 1939, pro-Coughlin picketers, who maintained a daily vigil at WMCA, marched to Times Square, where they started a "series of running fist fights," according to the *New York Times*, targeting people who were selling anti-Coughlin publications.

In February 1939, a Nazi rally at Madison Square Garden drew twenty thousand people. It was sponsored by Fritz Julius Kuhn's German-American Bund. That gathering was recounted in the 2017 documentary film *A Night at the Garden,* directed by Marshall Curry and produced by Laura Poitras and Charlotte Cook. The vintage footage resembles newsreels of Hitler, complete with a sea of arms raised in *sieg heil.* The only difference from Leni Riefenstahl is the rear of the stage is bedecked with American flags.

Thuggery was rampant in New York City through 1939. It was documented in the best piece I've read on this period, "The American Fascists," a nine-thousand word *Harper's Magazine* article published in 1940 by Dale Kramer, a newspaperman from Iowa who wrote nine books ranging from a study of farm protest movements to biographies of Heywood Broun and Harold Ross, cofounder and editor of the *New Yorker.*

After doing a lot of digging, Kramer wrote,

> An analysis of police court records reveals an amazing story—to a large degree kept from

> the public by a belief on the part of newspaper editors that the less said about it the better. Gangs of young hoodlums rove subway platforms late at night insulting Jews. A favorite tactic is to make jibes at a Jewish girl in the presence of her escort; the swain, thus provoked, attacks and is beaten by superior numbers. One youth, Irving Berger by name, was dangerously stabbed in such a fight in Grand Central station.

An offshoot of the Christian Front was the Christian Mobilizers. The two groups had numerous members. "In August the police, who by now were keeping a 'fever chart' of fascist doings, reported to Mayor [Fiorello] LaGuardia that 50 meetings with total attendance of over 20,000 were being held weekly," Kramer wrote. The reporter in Kramer was interested in hard facts. "More than [230] persons were prosecuted during the summer of 1939 in connection with the outbreaks and 101 were convicted. The record shows, somewhat ironically, that more persons felt the weight of the law in fighting against the fascists than fascists themselves. Prosecutions stood: fascists 106, opponents 127."

A depression is gasoline on the fire for hate movements in any era and place on earth. *The economy, stupid,* as James Carville famously said in 1992. I recall the conversation I had about the local economy in Denison, Iowa, with Nathan Mahrt, from his perspective of having been mayor of a small city, and how the situation there mirrored that of the nation. "What's crazy is just because you put your head in the sand doesn't mean shit ain't happening," Nathan said in response my saying we had just kicked the can down the road as a society. He added, "And sooner or later that can kicks you back." Dealing with hate groups is really a question of economic fairness, that if a broad range of Americans are sharing in the wealth of a society, hate

groups remain at the margins and have trouble recruiting new members. I've published the final paragraph of Kramer's article elsewhere, but it bears revisiting, both for its prediction (accurate, but off only in that it would take decades for it to transpire) and its message.

> It will take time for a powerful movement to organize itself out of the confusion caused by the war. But the [technique] of prejudice politics has been so well learned that should economic insecurity continue there can be no doubt that the American people during the next decade will be forced to deal with powerful "hate" movements. Great vigilance will be required to preserve our liberty without giving it up in the process.

VIII
NEW YORK CITY

RECALIBRATING

*Watching coal-miners at work, you realize
momentarily what different universes different
people inhabit. Down there where coal is dug
it is a sort of world apart which one can quite
easily go through life without ever hearing
about. Probably a majority of people would
even prefer not to hear about it. Yet it is the
absolutely necessary counterpart of our world
above. Practically everything we do, from
eating an ice to crossing the Atlantic, and from
baking a loaf to writing a novel, involves the
use of coal, directly or indirectly. For all the
arts of peace coal is needed; if war breaks out it
is needed all the more. . . In order that Hitler
may march the goose-step, that the Pope may
denounce Bolshevism, that the cricket crowds
may assemble at Lord's, that the Nancy poets
may scratch one another's backs, coal has got
to be forthcoming. But on the whole we are not
aware of it; we all know that we "must have
coal", but we seldom or never remember what
coal-getting involves.*

—George Orwell, *The Road to Wigan Pier*

In Los Angeles you can live behind gates and walls in the canyons
that cleave their way from Mulholland to Sunset, drive down to
Trader Joe's and Whole Foods, and then ascend back to the realm
of the stars, utterly avoiding exposure to the unpleasantness

of people living out of motor homes and cars in places such as the South Grand Avenue corridor along the 110 freeway. To the north, in the heart of the Silicon Valley, poor people are carefully regulated. The city of Palo Alto passed a "sit-lie" ordinance in 1997, which forbids sitting or lying down on a sidewalk, but the real reason was an end run to ban panhandling, which would have been unconstitutional; the measure was upheld by a judge. In 2013, the city outlawed sleeping in a car. The city further regulates its streets in the area surrounding University Avenue, using a passive-aggressive color scheme, with signs designating Purple, Coral, Lime, and Blue zones. The limit is two hours— if visitors move cars anywhere else in these zones between the hours of 8 A.M. and 5 P.M. on the same day, they will be ticketed. Most homes have driveways and don't require on-street parking, but residents don't want outsiders using the plentiful empty spots. My African American students who drove into the city from the direction of East Palo Alto back in the 1990s, when that impoverished city was over 40 percent black (it's now something less than 17 percent), told me of being repeatedly stopped by Palo Alto cops; once they showed Stanford identification, they were allowed to drive on.

The rich have been walling themselves off, literally or figuratively, for a long time in California. I wrote about one of the earliest walled "communities" for *Mother Jones* magazine— Monarch Bay in Dana Point, California, which I initially saw in 1980. "Since my first visit, walls have proliferated," I wrote in the 1994 article. "Roughly one-third of the 6.1-square-mile coastal city is sealed off behind 17 walled—or, in local parlance, 'gate-guarded'—communities. A Latino neighborhood sits right in the city center." The walls evoked the feeling of San Salvador, the capital of El Salvador, where I covered the civil war in 1984. Joan Didion observed that the oligarchs of San Salvador were hidden behind walls that they kept adding height to, "walls built upon walls," as their level of fear escalated.

In New York City, even if you live on Park Avenue or the Upper West or East Sides, or commute from Westchester County, you can't avoid the poor. Poverty is in your face not only in the form of panhandlers but in the sleep-deprived immigrants riding the subway to a second or third job, the immigrant on the electric bicycle who brings Grubhub or Uber Eats deliveries to your door, the people working in the bodegas and markets, your Lyft or Uber driver. You have to cultivate a willful blindness not to have this impact your psyche—in essence, you have to build imaginary walls to avoid thinking about the great class disparity that defines the United States. New York City is more akin to the third world, a place where you are forced to encounter poverty. From an op-ed I wrote for the *New York Times* in 1991:

> The panhandlers are just the outcropping of a greater problem of general poverty. They are the most visible reminders of the nightmare where they came from—tenements in Harlem or the Bronx. They drift down like messengers to remind us that all is not well, each representing hundreds or thousands of shattered lives hidden from our view.
>
> I wonder if things are any different now than on a cold, windy day in December 1881, when Leo Tolstoy descended into the heart of the destitution of Moscow, the Khitrov market. Horrified by the condition of a group of beggars, he emptied his pockets, and a minor riot ensued. He went to a friend's home seeking solace. The friend told Tolstoy that the poor were an "inevitable condition of civilization." Tolstoy, with tears in his eyes, cried out: "One cannot live so; one cannot; one cannot!"
>
> Tolstoy eventually wrote "What Then Must We Do?" In that book, he asked what a society

can and should do about poverty. The question is as valid today: what then must we do?

But what does society do? We sweep the homeless from the subways. Our liberal Mayor, David Dinkins, supports the plan. So do many otherwise progressive citizens. Only the most ardent friends of the homeless oppose it.

I have a file, now two inches thick, documenting sweeps all over the country. I've stopped adding to it because sweeps are no longer news. We do not stop the problem. We sweep it from sight.

The solutions are obvious: increasing the minimum wage, housing, mental health facilities, education, etc., etc. You know the answers.

Yet liberals and conservatives alike condone an intolerant society. The police, at the request of liberals and conservatives, tear down shantytowns; at least in the 1930's, we let the homeless have their Hoovervilles. Our elected officials, at the request of liberals and conservatives, oppose shelters or low-cost housing to the battlecry of "not in my backyard!"

We all hate them, as a society.

When we close our eyes at night we sweep them from out sight. But they will not go away.

Early in my academic career, when I taught in the small journalism program at Stanford University, I likened myself to being the hound dog in a house of poodles. I wasn't at all like my colleagues in the larger two departments in our building. To the best of my knowledge, they all grew up in upper-class and privileged homes; they went to elite universities. I was still young enough to be critically aware of my blue-collar upbringing. I was the son of a mother who drove a school bus and a father who

was a steelworker. This feeling of being an outsider faded in the ensuing decades, as I grew into my life of class privilege, of gaining tenure as a full professor at an Ivy League university and all the security, both monetary and psychological, that attends this level of status—having "one of the last great jobs left in America," as a friend, Michelle Gittelman, an associate professor in the Rutgers Business School, says. In other words, I lost sight of the awareness that I would have been fucked at birth were I born in a different era.

When I drove across the George Washington Bridge that spans the Hudson River, I returned to a changed city. It wasn't just temporary Covid-19 closures—favorite restaurants had permanent OUT OF BUSINESS signs. Whole blocks were bleak. Anecdotally, people were fleeing the city—forever, I learned from friends; data later proved there was a significant exodus. The *Times* reported moving companies couldn't keep up with demand. Homicides were up. It had a feeling of being headed for the New York City of the infamous *New York Daily News* headline in 1975, "Ford to City: Drop Dead," when the president said he wouldn't bail out the bankrupt city suffering from a loss of jobs and middle-class flight.

Not long after getting back, I had socially distanced outdoor drinks with a few recently graduated students. Soon, I was, showing them the pictures on my phone from the desert. When I swiped to the graffito, Megan Cattel rapidly said, "That's the millennial rallying cry." Megan and another student once had jobs housed in a WeWork space. They fantasized about the building being abandoned and their being able to squat there. "The showers are amazing," Megan said. There would be a lot of empty buildings in Manhattan—companies were bailing or never again planning on having office space—so their fantasy didn't seem far-fetched. Megan wondered if our school would

be holding in-person classes—an incoming student was a friend of hers and worried that classes would be virtual. Others told me that prospective students were considering deferring if classes were entirely online.

This was a significant national issue that affected hundreds of thousands of college students across the country. Harvard University announced early in the summer that all courses would be held online. At that point about one-third of the universities would hold online-only classes; that percentage would increase as fall neared. A *New York Times* story questioned the future of higher education and documented widespread rebellion. At least thirty families had filed lawsuits against major universities. "This is a moment that is basically forcing students and parents to say, 'What is the value? If I can't set foot on campus, is that the same value?'" Marguerite Roza, director of the Edunomics Lab at Georgetown University, asked. The newspaper quoted an incoming freshman at the University of Wisconsin—Madison: "Who wants to pay...for glorified Skype?"

The Graduate School of Journalism at Columbia University announced, as did some other schools, that we'd have "hybrid" teaching—that is, some classes being held in person, with strict protocols for mitigating risk, and other courses online. An administrator asked if I would be willing to teach live and I readily agreed: I believed I had already had the virus, and if I didn't have immunity I certainly would have caught Covid-19 given where I'd just traveled; the school was taking great safety measures; studies showed that if masks were worn, the danger was minimal; I am a journalist—that is, if there is an explosion, we journalists run toward it, not away. I was drawn into an email chain of a select group of my colleagues, most who wanted school to be 100 percent on Zoom. Some of them were in high-risk categories because of health issues. Of course I respected their choice and I told them this. But when I said I wanted to teach in person, and participate in the hybrid model, I was on the

receiving end of indignant and angry emails. I replied that "going fully online would not be a worthwhile experience and we would be ripping off the students. If we were to go fully online, I suspect the melt would be stunning. We'd have few students. The school would bleed money...If the school were to go fully online, I would push that we cancel the year."

No one addressed my question about cancelling the year. Nobody seemed concerned that turning into the University of Phoenix of journalism might hurt us all, especially our students. And nobody seemed willing to give up their paycheck. The base tuition in our master of science program is $68,960. The median scholarship awarded to M.S. students is $30,000, with 65 percent who apply getting some funding. Even if a student "only" has to pay $38,960, there are costs beyond tuition: fees and living expenses add roughly $47,000. Did we as professors only consider the money deposited into our bank accounts every two weeks and not think about the value for students? It goes without saying the pandemic raised deep concerns about returning to classrooms, but the fact that the underlying and undeniable damage of a Zoom education couldn't be acknowledged exposed the privilege and entitlement in which we lived.

An inevitable arrogance accompanies class privilege. We can condemn Kenneth Sullivan, the CEO of Smithfield Foods, who wrote to the governor of Nebraska that "social distancing is a nicety that makes sense only for people with laptops," and feel righteous anger about Sullivan not caring for the thousands of workers crammed into his meat-processing plants. But are we—those of us perched in tenured jobs, who run companies, or who do other work on Zoom—really any different from Sullivan? If we eat pork, we want it on our plate. We expect Dulce Castañeda's father to report to work, standing shoulder to shoulder in near freezing conditions with others chopping at carcasses, to ensure that supermarkets are stocked with meat when we shop during a pandemic. We expect the clerks in that market to be there to ring

up the pork chops or sausage (or vegan patties), exposed for eight or more hours per day to hundreds of customers just a few feet away, some of those customers unmasked in utter disregard for the life of the person at the register. If we've remained isolated at home, ordering all of our food delivered, we expect someone on a farm to pick the vegetables and fruit, then someone in a warehouse to load the boxes, and a driver to bring those boxes to us.

We expected Ian Beniston's father to have been on the job, back before U.S. Steel's Ohio Works was shuttered and razed, making the rebar that may be in the foundation of the home you now dwell in or the building where you work. We, as a society, did nothing to help Mr. Beniston and the other fifty thousand steelworkers who lost jobs in the Mahoning Valley, who were forgotten by the rest of us, if ever they were acknowledged; they grew bitter and angry, as did many of their children. And we were surprised when a great number of them reminded us of their presence and cast votes for Donald J. Trump.

Many of us in California will be horrified to witness the biblical expansion of homelessness in the Bay Area and Los Angeles Basin in the wake of upcoming evictions, something that will overwhelm the resources of Joe Smith at Loaves & Fishes, Mel Tillekeratne at the Shower of Hope, and many other nonprofits. Yet some Californians in early 2020 applauded the demise, yet again, of a bill in the state senate that would have increased housing density in public transit corridors by overriding local zoning ordinances. Three times since 2018, state senator Scott Wiener, a San Francisco Democrat, has tried to get the bill passed, only to face opposition from his own party, who bow to the interest of so-called liberal suburbanites and city dwellers in the overwhelmingly Democratic-leaning coastal counties. Opponents throw up terms such as "local control" and "gentrification." But those are dog whistles for a fear of lower property values and/or people of a lower class status residing too close.

We prefer to live in our own private Idahos. We don't want to see the homeless or the underhoused working class crowded two families or more per dwelling. Nor do we want to think about the meat-packing plant or warehouse workers, the clerks, the delivery drivers, just as those in Great Britain in the time of Orwell didn't want to know about coal miners. The Left Book Club, an English socialist group, sent Orwell to study poverty and joblessness in northern England in 1936. He went beyond his mandate and looked at those who had jobs, descending into the coal mines and angering his sponsors in large part because Orwell not only questioned socialism, he explored class. "In a way it is even humiliating to watch coal-miners working. It raises in you a momentary doubt about your own status as an 'intellectual' and a superior person generally," Orwell wrote.

We who call ourselves liberal, in the top 15 percent or so income bracket, cannot simply point fingers at Republicans and conservatives. We are a nation of Karens, both with regards to Black Lives Matter, and class.

What then must we do?

The subtitle of this book is not meant to herd the reader toward a long list of prescriptive solutions. That is a task for another volume ten times the size of this one, and it would be a useless exercise regardless. What needs to be done is already known. The intention of my journey was to hear directly from the people I met on the road. In their responses we see that we must recalibrate the American dream so that there is a level playing field—there is no avoiding that—and other clichés such as creating true equality— revitalizing those tropes to actually mean something again for a wide range of Americans. As John Russo says, that is the contested ground that will define the choice we have in the next midterm elections, and in 2024. The starting point for us all, then, is to actually see the people in poverty and to integrate them into

the notion of a healthy economy, one that works for everyone, rather than just for the top tier.

For years I wished to have been born in the early days of the last century, so I could have been a writer in the 1930s, a dynamic time when crisis forced some social change, and writers, including James Agee, Louis Adamic, and George Orwell, explored how working-class people were coping. I've lived long enough to now be a writer in this century's '30s. The 2020s present us with the unfinished business of the 1930s. Dale Kramer, the now-forgotten newspaperman who reported the story on American fascism, so wisely predicted the rise of hate movements. World War II ended the Great Depression and those movements—for a while—but not the problems inherent in our culture. The New Deal alleviated a lot of suffering, but it didn't go far enough; nor did it address the issue of race—segregation, unequal schools, the racial disparity that also leads to economic injustice. It didn't bring universal health care, either, though Franklin Roosevelt tried to attach a federally funded health program to the legislation that created Social Security; the American Medical Association shot that idea down. Roosevelt acquiesced to get Congress to pass the Social Security Act.

The wish list goes on: federally funded day care, a minimum wage indexed to inflation, a Green New Deal, a Black Lives Matter New Deal, etc, etc. These things appear to be on hold in the contested terrain of the next few years. The dream of a Democratic wave election in 2020 vaporized. A Republican-majority U.S. Senate, unless the two yet-undecided seats in Georgia are won in a runoff election in 2021, will surely block attempts to help the working class by the Biden-Harris administration before the midterm election, which could give Democrats another chance at controlling the chamber. The collapse and fragmentation of the post-Trump Republican Party might provide the hapless incremental Democrats a window to affect change. Or will Democrats, as usual, crumble in division amid calls from some in

the party to be more "centrist" to appeal to the seventy-one-some million people who voted for Trump in 2020? That would be a grave mistake. Many of those now-Republican millions rioted at the ballot box in a cry for help. Oatmeal politics won't win them over in 2024. Being Republican-light would be fatal. It's time for a bold agenda, not capitulation. Action means creating good jobs. One successful employment model that I've documented is the Evergreen Cooperative Corporation, owned by its workers, in Cleveland: it's a hybrid form of capitalism that has the potential to create hundreds of thousands of jobs in America. If Democrats embraced such an initiative, it would transcend the power of the New Deal in the 1930s—it would help recalibrate the American dream so that the wealth is shared, and the hard-core one-third or so of the country that favors authoritarianism/fascism is crushed and left to wander in the Fox News wilderness for another seventy to eighty years, when we once again may have to confront the unresolved issues of the 1930s and 2020s.

In any event, we have to get to a place where people can dream about a better life, the trait that so wrongly dismayed James Rorty in 1935. I realized this one day when I was talking on the phone with one of the friends I had isolated with in Southern California, seated with my back against the trunk of a towering linden tree. I was now staying with other friends north of New York City, on a five-acre property of woods and grass. It was a hot and muggy day. There was the sound of a truck pulling up outside the front gate. I looked up and spotted a UPS driver coming on foot up the long drive with a package. I rose and went across the vast lawn to meet him. I shouted hello.

"You are a gentleman and a scholar!" he exclaimed when he looked up, thanking me profusely for saving him the rest of the walk. He wiped his sweaty forehead and thanked me again. "I started working at two o'clock this morning," he said. It was now just after 4 P.M. He had more deliveries remaining. "At least I'm getting the paycheck."

"I hope it's a big one," I said, adding that delivery guys like him have it hard and he deserved all the money he could get.

As he walked off, he spoke without malice, only desire, invoking the spirit of the people Rorty found eight decades earlier:

"I want to end up living just like you."

Dale Maharidge
New York City
November 10, 2020

ACKNOWLEDGMENTS

Grateful acknowledgment for both financial and other support to the Economic Hardship Reporting Project and its executive director, Alissa Quart, and managing director, David Wallis; senior editor Lizzy Ratner at the *Nation*; Julian Rubinstein for his help in Denver. And to those organizations and people who assisted along the way: Loaves & and Fishes in Sacramento, and its advocacy director, Joe Smith; Mel Tillekeratne and the Shower of Hope; Gary Blasi, emeritus professor of law at UCLA; Joel Hodge and the Struggle of Love Foundation; Terrance Roberts; Dulce Castañeda and the Children of Smithfield; Nathan Mahrt, ex-mayor of Denison, Iowa; Safe Parking LA and associate director Emily Kantrim; Ron Bruder as always for his generous hospitality; and all those left unnamed who helped in other ways. Special thanks to John Russo and Sherry Linkon, affiliates of the Kalmanovitz Initiative for Labor and the Working Poor at Georgetown University; Julie Naughton at the Nebraska Department of Health and Human Services; photographer Paul Grilli for his help in Youngstown; C. P. Heiser, publisher and cofounder of the Unnamed Press, who is a writer's dream editor; my tireless agent Jennifer Lyons, of the Jennifer Lyons Literary Agency, LLC.

About the Author

For nearly four decades, Dale Maharidge has been one of America's leading chroniclers of poverty. Alongside photographer Michael S. Williamson, his book *And Their Children After Them* won the Pulitzer Prize for General Non-Fiction in 1990, revisiting the places and people of Depression-era America, depicted in Walker Evans's and James Agee's *Let Us Now Praise Famous Men*. Also with Williamson, Maharidge produced *Journey to Nowhere: The Saga of the New Underclass*, which Bruce Springsteen has credited as an influence for songs such as "Youngstown" and "The New Timer."